CREATING WORLD-CLASS PHOTOGRAPHY

How Any Photographer Can Create Technically Flawless Photographs

Ernst Wildi

AMHERST MEDIA, INC. BUFFALO, NY
SOMERSET CO. LIBRARY
BRHDGEWATER, N.J. 08807

Copyright © 2001 by Ernst Wildi.

All photographs by the author unless otherwise noted.

All rights reserved.

Published by: Amherst Media, Inc. P.O. Box 586 Buffalo, N.Y. 14226 Fax: 716-874-4508

www.AmherstMedia.com

Publisher: Craig Alesse

Senior Editor/Production Manager: Michelle Perkins

Assistant Editor: Barbara A. Lynch-Johnt

ISBN: 1-58428-052-2

Library of Congress Card Catalog Number: 00 135887

Printed in Korea.

10 9 8 7 6 5 4 3 2 1

No part of this publication may be reproduced, stored, or transmitted in any form or by any means, electronic, mechanical, photocopied, recorded or otherwise, without prior written consent from the publisher.

Notice of Disclaimer: The information contained in this book is based on the author's experience and opinions. The author and publisher will not be held liable for the use or misuse of the information in this book.

Previously published as *Achieving the Ultimate Image* (Amherst Media), this volume has been updated with new information and photographs.

TABLE OF CONTENTS

Introduction5	Quality at Different Distances
	MTF Diagrams
I. Film or No Film	Illumination
The Point & Shoot Approach	
Digital Imaging for Serious Work	Image Distortion.30Teleconverters.33
2. Films for the Ultimate Image Quality 10	
Evaluating the Final Image	7. Effective Use of Lenses and Lens Controls35
	Choice of Lens Aperture
3. Selecting the Film Format	Image Sharpness at Small Apertures35
The Large Format	Depth of Field
The Medium Formats	Focus
35mm	Manual Stop Down Control
The Advanced Photo System (APS)17	Background and Foreground Sharpness 42
	Zoom Lenses and Zoom Effects
4. Camera Features	Lenses for Area Coverage
Shutters	and Perspective Control
Viewfinders	Effective Wide-Angle Photography
Focusing Screens	Fisheye Photography46
Motordriven Film Advance	Straightening Verticals
5. Camera Operation for Image	8. Achieving the Ultimate Exposure50
Quality and Effects	Light Meters50
Successful Handheld Photography	The Metering Approach55
Mirror Lockup	Advantage of TTL Metering
Tripods	Built-in Metering Methods
Selection and Use of Shutter Speed	Use of Automatic Exposure Cameras58
*	The Zone System60
6. Lenses for Creating the	
Ultimate Sharpness	9. Location Flash Photography
Lens Design	Manual Flash
Apochromatic Lenses	Automatic Flash
Wide-Angle Design28	Dedicated Flash
Zoom Lenses	

CREATING WORLD-CLASS PHOTOGRAPHY

Making the Existing Light	Lines
Part of the Picture	Attention-Creating Elements99
Flash Exposure	Keep the Image Simple
Subject Brightness69	
Film Reflectance	14. Beyond the Picture Postcard
Producing Better Flash Illumination	Improved Scenics
Color of Light and Flash	Photographing People
Multiple Flash	
Flash Applications	15. Photographing People Outdoors
Indoor Flash Photography	Lighting
	Location and Background116
10. Close-Up Photography	The Professional Touch
Magnification	
Close-Up Lenses	Glossary119
Extension Tubes and Bellows	Index
Depth of Field with Different Lenses	
and Close-Up Accessories	
Photographing Subjects Life-Size78	
Photographing Close-Ups	
Lighting	
High Magnification Photography	
II. Filters for Better	
Image Quality and Effect	
Filters in Black & White Photography 82	
Neutral Density Filters	
Light Balance and Conversion Filters	
Haze, UV and Skylight Filters85	
Polarizing Filters85	
Partial Filtering	
Filters for Infrared Photography	
Exposure Increase	
Quality of Filters89	
Special Effect Filters	
Working with UV Light	
12. Professional Soft Focus Photography 91	
Soft Focus Lens or Soft Focus Filter?	
Creating Effective Soft Focus Images	
13. Enhance the Image	
with Effective Composition	
Composing in the Square	
Subject Placement	
Balance	

INTRODUCTION

PRODUCING WORLD-CLASS PHOTOGRAPHS MUST BE THE GOAL OF EVERY SERIOUS photographer working with any type of camera equipment. Achieving the ultimate image on film or electronically means creating an image that is technically perfect and visually inspiring. If you do photography as a hobby, achieving this goal may mean nothing more than creating an image that pleases you—the creator of the image. Naturally, your photographic hobby becomes more rewarding if the images also bring enjoyment to others. It should convey to your friends, family members, or members of a camera club that you know what to do with your camera.

For the professional, it is important that the image pleases the client. It needs to convey the message that the client is trying to get across, such as in an advertisement. It can convince the client that you are the professional that should be considered for future assignments. Such an image must have visual impact, mainly determined by your artistic sense for design and color. The image must also be free from any technical faults that may distract from the impact or enjoyment of the image.

This book covers the points that are important for creating such an image with any camera. It does so in a simple fashion, without going into details about camera design, or the features and operation of specific cameras, lenses and accessories. You can find that information in your instruction manual. I also assume that you know and understand the basics of photography and the use of cameras. I limit my text to how this knowledge is applied for creating good looking, exciting photographs.

The book will inspire you to look for new, exciting picture ideas and to record ordinary subjects in a different way, thus, achieving the ultimate image technically as well as visually.

The information, approaches and techniques discussed in this book apply to any camera and film format, especially 35mm. With the exception of the chapter on film, they also apply to both digital and film work. Most of the images in this book are made in the medium format with Hasselblad equipment, since this is the camera that I have used for many years.

PRODUCING

WORLD-CLASS

PHOTOGRAPHS

MUST BE

THE GOAL

OF EVERY

SERIOUS

PHOTOGRAPHER.

FILM OR NO FILM

NTIL RECENTLY, PHOTOGRAPHY ALWAYS MEANT RECORDING IMAGES ON transparency or negative film, then projecting the slides on a screen or producing either black & white or color prints from negatives in the darkroom. Most special effects, such as changes in color, multiple exposures and blurred motion, had to be created when recording the image.

Today, we have the second possibility of recording the images electronically, viewing them on a computer or TV screen, or producing prints without film, photographic paper and without a darkroom. Unlimited special effects can be electronically added later. You can save on film and processing costs while helping the environment, since there are no chemicals involved.

Practically all of the information in this book also applies to electronic imaging with these cameras. Be aware, however, that because the size of the digital image may be smaller than a 35mm frame the standard lens (50mm on a 35mm camera) becomes a telephoto. A lens with a focal length somewhere around 25mm will cover the same area as the standard lens for 35mm. Since the size of the CCD or CMOS in digital cameras or camera backs varies, manufacturers frequently do not indicate the actual focal length of the lens on the specification sheets. They show instead the

For a working photographer, the questions is: "Should I change to electronic imaging or add electronic imaging to my present photographic involvement?" Although electronic imaging is fairly new, there is an avalanche of equipment available both for serious professional work as well as for the point & shoot approach.

focal length, or focal length range, that is equivalent to the 35mm film format. So a first question for the newcomer is: "Which way should I go, film or digital?"

■ THE POINT & SHOOT APPROACH

There is a wide range of digital cameras that are very much like point & shoot film cameras. They look similar, are about the same size, and weigh about the same: between five and twelve ounces. The features on these cameras are very similar usually providing automatic exposure, automatic focusing or fixed focus, some with zoom lenses, some with flash. On some models, the image is viewed through an optical finder. On others, the image is displayed on an LCD panel so you can see what the final image will look like. A certain number of images can be stored in memory in the camera. Some cameras offer the opportunity to store more images on PC cards. The images can later be viewed on the computer screen. You may

SO A FIRST

QUESTION

FOR THE

NEWCOMER IS:

"WHICH WAY

SHOULD I GO,

FILM OR

DIGITAL?"

have the possibility of retouching or manipulating the images with imaging software and making prints yourself, or having them made at a digital workstation. While we are not talking about serious photography here, you may very well want to add such a digital point & shoot camera for your personal work, for family snapshots, or for just having fun.

If you plan to add such a digital point & shoot camera, look at the various models. Try them to see which one is most enjoyable in actual use. Look at some of the specifications—especially how many images can be stored, how fast the camera cycles, whether the images can be downloaded into your computer, and the resolution capability, which determines the image quality.

■ DIGITAL IMAGING FOR SERIOUS WORK

For photojournalists and some professional photographers in the commercial and fashion photography field, electronic imaging is nothing new. High quality digital cameras have been available for a few years; new models are added constantly. Many of them are built around an established 35mm camera. Camera operation and the actual recording of the image is done in the same fashion as with film.

The images are stored digitally and can be downloaded into a computer. Image processing, data transmission, and printing are accomplished within a very short time. This is an advantage in advertising photography. An ad with images can be completed and ready for printing within two to three hours from the moment the image is made in the camera. The usually tight deadlines for newspapers and magazines are a major reason why photojournalism has moved to electronic imaging. Another is the possibility of transmitting these digital images immediately to other places around the globe.

When considering digital equipment for your work, you must determine before-hand what it will be used for and especially what size prints you need for that application. Then check the specifications, or even better, actually try it in a typical application, and make prints in the size you need. Basically, it is the same recommendation that is made for film photography when you are selecting a certain film format and/or piece of equipment for a specific application. You may not want to use 35mm if you need gigantic enlargements, but instead shoot the original in the medium or large format, providing the necessary sharpness for the blowup.

Digital Imaging in the Medium and Large Format. Medium and large format photographers have been able to produce images electronically for some time by simply attaching a special electronic imaging back to existing cameras. There is no need to buy a new camera or camera system. You use the same camera, lenses and accessories that you use for film.

You must, however, study the specifications for the digital back. Some are only usable with specific camera models, even among those made by the same company. You may need a motordriven camera. You may have to be directly connected to the computer, limiting the photographic work to the studio. Others can be taken into the field, recording the images on a PC card. You must also check whether the image is scanned or recorded instantly in all colors. The latter will allow photography of moving subjects and the use of electronic flash. Also check the size of the

FOR

PHOTOJOURNALISTS

AND SOME

PROFESSIONAL

PHOTOGRAPHERS,

ELECTRONIC

IMAGING

IS NOTHING

NEW.

CCD or CMOS. Most are more the size of a 35mm frame than a medium format one. If this is the case, standard lenses record like telephotos. To record the standard frame, the lens must have a wide-angle focal length.

Resolution. Just as in film photography, resolution is a determining factor for image sharpness. In digital photography, resolution is mainly determined by the number of pixels. This explains why this number (rather than the size of the CCD or CMOS) is always found in cameras' specification sheets. A camera with a number of 640 x 480 produces a total of 307,200 pixels. This number is considered a low resolution, but satisfactory for snapshots, or pictures to be used on a website or sent via e-mail.

For good quality prints (even a small 4" x 6" (10cm x 15cm)), you may want to consider something higher—such as 1600 x 1200. For larger prints or professional-looking quality in any size, consider a camera with about three million pixels (a three-megapixel type). Today, you will find cameras in the 35mm format, or camera backs for medium and large format cameras with numbers like 2048 x 3072—which adds up to an impressive 6,291,456 pixels. An image produced with such equipment is free of grain and can match—perhaps even exceed—the sharpness of an image made on film. Just as with film, the sharpness of the final image is also affected by the quality of the other equipment—especially the printer.

Making the Decision. In some fields of professional photography, or for some professional applications, digital imaging has proven its definite advantages and can be considered (or is already) a replacement for film photography. This is the case, for example, when the results are needed immediately, or need to be studied and evaluated while shooting, or when the results must immediately be transmitted to another location (such as in news photography). For most other applications, however, recording images electronically is an exciting addition (not a replacement) to film photography. Even if you continue to record your images on film, as you probably will for some time, a serious photographer—especially a professional—must study the new possibilities of electronic imaging. Keep up to date, see what is possible, and see what the competition is doing.

To an amateur photographer, a digital camera (or working with image manipulation on a computer) may very well bring new excitement to photography. If image manipulation has become your new interest, you must of course keep in mind that the original image need not be made with a digital camera. Any image on film can be changed into a digital image—and you can do it yourself or have it done at a digital workstation. If your main interest remains to record and present subjects as they actually are (as I do), film is still an excellent—even the perfect—choice.

You can select the type of film that is best for each situation—films of extremely high sensitivity to work in low light, a film that produces either transparencies or negatives in either black & white or color. While film processing is not instant, the time it takes has been shortened dramatically. Thousands of film images can be stored and filed for as long as you want, in a convenient, inexpensive fashion.

While it is possible to create specific images and correct mistakes in an original image in the computer, I still believe in trying to accomplish the desired results in the original image. You can, for example, straighten out slanted verticals in an archi-

JUST AS IN FILM

PHOTOGRAPHY,

RESOLUTION IS A

DETERMINING FACTOR

FOR IMAGE

SHARPNESS.

tectural picture in the computer, but it is much easier—and less time consuming—to do it in the original image with perspective control equipment. You can also use several images to produce a panoramic image on the computer, but a better solution is producing the images with a panoramic camera (if available). While there is image sharpening software available, it only works with images that are sharp. You cannot make a sharp image from an unsharp original.

Selecting Digital Equipment. The choice of digital camera is basically made by asking yourself the same questions that you would ask when deciding on a camera for film recording. For example, if you or your client requires the ultimate image quality, or if large prints are needed, you'll want to consider a medium or large format camera instead of 35mm. In digital, the pixel number becomes a main consideration in such a case. Some questions to ask are: What do I want to use it for? What kind of pictures do I want to make with it? What camera features and lenses are necessary for this work? How will the images be used or seen? Who will see them? What does the client want? What size prints are needed, and what should the quality be?

If you choose to go digital, study the manufacturers' specification sheets, the published write-ups and test reports to determine what is right for you. I will not go into details on digital cameras, because new developments in this field happen so quickly that this book might be outdated by the time it comes off the press. The use of the digital camera and its lenses, however, does not change and does not differ from working with film, so this book should also help you produce effective images in a digital fashion.

I STILL

BELIEVE IN

TRYING TO

ACCOMPLISH

THE DESIRED

RESULTS

IN THE

ORIGINAL

IMAGE.

FILMS FOR THE ULTIMATE IMAGE QUALITY

TODAY, AS IN THE PAST, IMAGE QUALITY VARIES WITH THE SENSITIVITY OF THE films. Films of lower sensitivity produce sharper images than those with higher ISO numbers. For producing the ultimate image sharpness in any film format, consider films with ISO 50 to 100.

However, the grain structure and the resolution of practically all the films we have today are far superior to those films that were available just five years ago. This superb definition allows us to record details and make gigantic enlargements unimaginable in the past. It also means that you should not hesitate to use faster films—400 ISO or higher if it helps you produce the desired results for your pho-

The light before sunrise conveyed a very peaceful feeling for this picture taken on ISO 200 film in the Canadian Rockies.

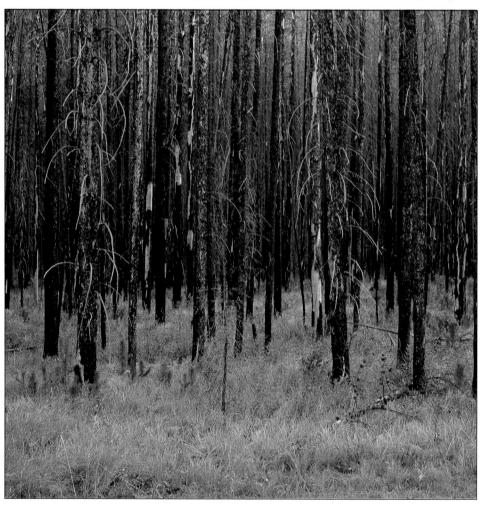

tographic approach. The sharpness of ISO 400 films today is what ISO 100 was five years ago.

Switching to a higher ISO film allows you to use a smaller aperture for greater depth of field, a shorter shutter speed to decrease the danger of camera or subject movement, to do handheld photography, or to work with a smaller flash unit. An image taken with ISO 400 film at f/8 may very well be visibly more effective due to the greater depth of field than one made at f/4 on ISO 100. If handheld photography is necessary or desirable, I prefer to use the shorter $\frac{1}{125}$ second shutter speed with ISO 400 over $\frac{1}{30}$ second with ISO 100.

Transparency films are generally recognized as sharper than color negative emulsions. Prints made directly from transparencies (especially in the medium format) also have the ultimate sharpness and contrast, but they are only made in special professional labs and at high costs, or in your own darkroom. Amateur labs do not

make such prints, or do so only by first making a negative (internegative) from the transparency. This process thus eliminates or reduces the advantages of shooting the original on transparency film. If you need color prints, it is most practical to use color negative emulsions with a low ISO.

EVALUATING THE FINAL IMAGE

The sharpness of a projected transparency is affected by the brightness and quality of the projector and its projection lens. If you want to show your slides with the corner-to-corner sharpness recorded in the camera, evaluate the sharpness features of the projector carefully. Consider a higher quality projection lens than the one that comes with the projector. When you tilt a projector to move the image on the screen up or down, maintaining sharpness from top to bottom is always a problem.

Perspective control built into a projector will eliminate this problem, but it is a feature that is hard to find. Projectors are readily available for 35mm, for the 6cm x 6cm and 6cm x 4.5cm medium format, and even for 6cm x 7cm.

The sharpness, contrast and overall quality of a black & white and color print is also greatly dependent on the film development, the quality of the printing equipment, and the paper and paper development. For ultimate sharpness in the final image, the quality of the printing equipment and materials must match the quality of the camera and lens. A larger film format is likely to call for better quality in the rest of the photographic equipment. Therefore, if a projected transparency or a print does not have the expected quality, you should first evaluate the negative or original transparency under a good magnifying glass. Its magnification should be 8x or better (10x). A 3x or 4x loupe is not sufficient for critical work.

Examine the negative or transparency carefully. Try to determine whether the deficiency of the quality that you noticed on the screen or print is visible on the original. This will likely reveal at what stage in the image creating process the problem is located.

Even if there is no sharpness problem with the final image, I recommend that you examine all your negatives or transparencies under a 8x or 10x magnifier. The mag-

Higher sensitivity films, such as ISO 400, have excellent sharpness without any objectionable or visible grain, especially in the larger medium format. Such films often allow handheld photography in low light situations, as here in the existing light inside a palace in St. Petersburg, Russia.

nifier does not need to be of a high optical quality, since you basically only view the center of the magnified image. However, a high quality type that may cost five or even ten times more makes such evaluation more enjoyable and more critical. You will be able to see more in this examination than you will ever see on the final image—for example, the difference in sharpness within the depth of field range and the difference in sharpness between ISO 100 and ISO 400 film. This constant check of your images will make you a very critical photographer.

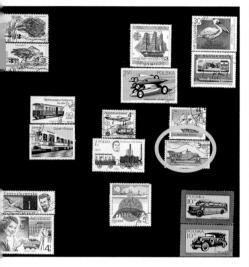

The enlarging capability with today's films is illustrated by the 10x enlargement of the postage stamps. The original was made in the 6cm x 6cm format on Fuji Velvia 50 ASA film. The original is pictured on the left, the enlargement is shown above.

SELECTING THE FILM FORMAT

EGARDLESS OF THE TYPE OF FILM IN THE CAMERA, IMAGE SHARPNESS IS dependent on the size of the image on the film. On a larger negative or transparency, the subject is recorded proportionally larger. The subject is spread over a larger area, revealing more details or revealing them in a sharper fashion. In principle then, a larger image format will produce a sharper image (assuming that everything else is equal). There are four major photographic formats: large format (4" x 5" and larger), the various medium formats, 35mm, and the APS (Advanced Photo System).

IMAGE

SHARPNESS

IS DEPENDENT

ON THE SIZE

ON THE FILM.

■ THE LARGE FORMAT

4" x 5" and larger is basically a professional format. It has been and is still used, OF THE IMAGE however, by many amateur photographers in the fine art field, especially for black & white work. Its importance, however, has been diminished because of the high quality of today's black & white and color films. The smaller film formats allow gigantic blowups that come close to the 4" x 5" quality. The negatives can also be produced in a smaller, more compact camera that even allows handheld work. The main advantage of working with large format view cameras today is in the cameras' shift and tilt capability.

■ THE MEDIUM FORMATS

Unlike 35mm, where all cameras produce the same 24mm x 36mm image size, medium format cameras are made for different image sizes. Some cameras provide a choice of two or three sizes with interchangeable magazines.

The medium format is about as old as photography. Daguerreotype plates were usually made in sizes between two and four inches. The folding cameras were made for the medium format (6cm x 9cm) and the box brownies were made for the 120 or 620 roll film. The medium format became established for serious photography with the introduction of the twin lens reflex (TLR) cameras, producing 6cm x 6cm square images.

Because of the superb resolution of today's films, some photographers and photographic educators feel there is no need anymore to move up from 35mm to the larger medium format sizes. I feel that the best reason for moving from 35mm to the medium format is exactly the superb sharpness of the films today. While 35mm images look beautiful, only a larger format can really convey the quality that is

This image was made using a 6cm x 6cm (2½" square) medium format camera. Compare this image size with the equivalent 35mm and APS image sizes at the top of the next page.

possible on these films. It is exciting to view medium format negatives or transparencies under a 10x magnifying glass. You can really experience what image sharpness means today.

The 2¼" Square Format. The 2¼" square (6cm x 6cm) format is still popular all over the world. The image area is more than 3½ times larger than 35mm. Square images also eliminates the need for turning the camera to shoot verticals and horizontals. This is a wonderful advantage while shooting, working from a tripod, or working with a portable flash unit attached to the camera. If properly composed, square images can be changed into verticals or horizontals later without losing sharpness. We are not cropping, just changing the shape of the image. On some

The image on the left was taken with a 35mm format camera. The image above was taken with the Advanced Photo System (APS). Compare these image sizes to the equivalent 6cm x 6cm medium format image size on the previous page.

square format cameras, you can also produce rectangular images in the 6cm x 4.5cm format with a different magazine or by inserting a mask.

The 6cm x 4.5cm Format. Some medium format cameras are specifically made for the 6cm x 4.5cm format, which has an image area about 2.6 times larger than 35mm. The long side of the negative is 56mm, 1.6 times longer than the 36mm long side of 35mm. Subjects on 6cm x 4.5cm (or 6cm x 6cm) are therefore about 1.6 times larger. Since the long sides of $2\frac{1}{4}$ square and 6cm x 4.5cm images are identical, image sharpness is equal, provided everything else is equal. $2\frac{1}{4}$ square and 6cm x 4.5cm cameras are compact and easy to use on location or handheld.

The 6cm x 7cm Format. A third popular medium format is 6cm x 7cm, with the long side of the negative or transparency 1cm longer than the 2½ square or 6cm x 4.5cm format; 1.9 times longer than 35mm. Theoretically, this format should produce sharper images, but the difference in negative size seem to be too small to make such a difference noticeable. The slightly larger image, however, can increase size and weight of the camera considerably. This must be considered in a medium format camera. It determines whether photography is a pleasure or a burden and whether the camera becomes strictly a studio type or an equally great tool for handheld location photography. This flexibility is what a medium format camera is suppose to produce.

6cm x 7cm, however, is selected often, especially for studio work, because of the rectangular shape of the image. Also, horizontals and verticals may be obtained by turning the film magazine, not the entire camera, and because of the camera shape, which may be more like a 35mm type.

Images made in the square format don't have to be presented as squares. Many images can be changed quite effectively into horizontals or verticals afterward. This change in format can also be made without losing image sharpness, since we only change the shape of the image, not the size of the subject recorded in the camera.

Other Medium Formats. Other image sizes that belong to the medium format field because they are produced on 120 or 220 roll film are 6cm x 8cm, 6cm x 9cm and the panoramic shapes 6cm x 12cm or 6cm x 17cm.

Interchangeable Film Magazines. The larger image size is a major reason for selecting the medium format. A second reason, and for many photographers this is equally important, is the camera design with interchangeable film magazines. With the film in a separate film magazine, which is removable at any time, you can switch from one type of film to another—even in the middle of a roll—without wasting or fogging the film. For example, you can switch from black & white to color, from low speed to high speed film, or from 120 to 220 or 70mm long roll films.

On most cameras, you can also attach a magazine for Polaroid® film. Shooting a Polaroid allows you to check the camera operation or the flash sync at any time. It also allows for complete image evaluation—especially advantageous when using slow shutter speeds to blur action, producing double exposures, or other effects that cannot be seen on the focusing screen.

Backs for electronic imaging can also be added to some cameras. While it is at present a costly proposition (intended only for the professional who needs this approach to satisfy a client), it is something you may want to keep in the back of your mind. It will allow you to go into electronic imaging without investing in a completely new and different camera system.

■ 35мм

35mm cameras produce excellent image sharpness for amateur and professional work on today's high resolution films. These images can also be enlarged to greater sizes without grain or unsharpness becoming visible or objectionable. But, since identical films are used in the medium format, the same quality difference between 35mm and larger formats still exists today.

35mm is an excellent choice for many professional applications and definitely for amateur photographers. The choice of camera is unlimited—from fully automatic, compact and lightweight models to the very sophisticated type with a wide choice of lenses and accessories. While some of the latter camera bodies with a built-in motor may weigh as much as some of the compact medium format models, lenses will be more compact and weigh less. This will be appreciated by the nature, wildlife or sport photographers working with long telephotos. The 35mm format offers the widest choice of films and the fastest lenses. In most focal lengths, such lenses may be one or two stops faster than equivalent focal lengths in the medium format. 35mm also gives you the widest choice of films, which are available worldwide.

There is one 35mm camera on the market, the Hasselblad XPan, that also allows the photographer to produce panoramic images in the 24mm x 65mm format on standard 35mm film. These images can be obtained on the camera in addition to the standard 35mm format, and the two can be intermixed on the same roll of film.

■ THE ADVANCED PHOTO SYSTEM (APS)

Cameras made for the APS system produce images on film loaded in a special cassette designed for completely automatic loading. All images on the film are the same size (16.7mm x 30.2mm), but they can be composed and later printed in three different formats: Classic (C) using the full 16.7mm x 30.2mm image area in the classic 2:3 ratio; HDTV (H) with a 9:16 ratio; or Panoramic (P) with a 1:3 ratio. While all images are smaller than 35mm, image sharpness has been found to be excellent—more than satisfactory for amateur enlargement.

The main advantages of APS are not in the photographic possibilities, but in the storing and printing convenience. The compact camera design is also a benefit that appeals to many people. However, these points are less important to serious photographers than the versatility and possibilities of creating interesting images of the highest quality. Consequently, this new format should not be considered at present for serious photography. The tools for creating professional images are limited or nonexistent in the APS format. You may, however, consider such a camera for your personal work.

CAMERAS

MADE FOR THE

APS SYSTEM

PRODUCE IMAGES

ON FILM LOADED

IN A SPECIAL

CASSETTE.

CAMERA FEATURES

AMERAS ARE AVAILABLE IN A WIDE VARIETY OF STYLES AND TYPES. YOU SHOULD have no problem finding one in your price range that has the essentials for producing your type of images in the best and easiest way. For serious work, you probably want to consider a single lens reflex (SLR) type where you can evaluate the image carefully on the focusing screen.

■ SHUTTERS

Shutters fall into two groups: the focal plane shutter (built into the camera), or the lens shutter (built into the lens). For most purposes, one is as good as the other. One concern, however, is flash synch speed.

A lens shutter will allow you to shoot with electronic flash at all shutter speeds. This is especially helpful when using flash outdoors in bright daylight. In the 35mm format, however, many cameras with focal plane shutters synchronize up to ½50 second or even 1/300 second, which is short enough for most applications. Focal plane shutters in medium format cameras are more limited, and usually provide flash sync only up to 1/60 second, or 1/60 second at best. You must, therefore, select the shutter type more carefully in the medium format.

Shutter speed, in the camera or the lens, can be controlled either mechanically or electronically. The latter is more reliable and accurate in cold weather. One must realize, however, that the actual shutter operation is always mechanical, and good mechanical shutters can be practically as accurate as electronic types—but they require more attention for service.

■ VIEWFINDERS

For achieving the ultimate image sharpness, the camera's viewfinder must be carefully evaluated. Regardless of the type of finder, you must be able to see the focusing screen on an SLR camera with utmost clarity. When you look through a camera viewfinder, you no longer look at the actual focusing screen but at an image of the screen, which is at a specific distance—usually from two to six feet. (Your instruction book may not give you this data, so check with the manufacturer of the camera.)

It is important to know this, as your eyes must be capable of focusing at this distance—and this is often not the case, especially with older photographers. Fortunately, on most cameras today, eyepieces are adjustable or interchangeable so that the eyepiece correction can be matched to your personal eyesight (note that

A LENS

SHUTTER

WILL ALLOW YOU

TO SHOOT

WITH ELECTRONIC

FLASH AT ALL

SHUTTER

SPEEDS.

astigmatism is seldom a factor in viewing through a camera viewfinder). Investigate this point carefully when you purchase the camera. The correction you may need has

no direct relationship to your eyeglass prescription, however, as the two are made for different distances.

Try the different eyepieces or obtain additional information from the camera manufacturers. Do not compromise on this point. Don't be satisfied until you have a solution that gives you the sharpest possible view. Most cameras today also have what is called a high eyepoint eyepiece. Such an eyepiece should allow you to view and focus with or without eyeglasses and always see the entire finder field.

Now you have the choice of leaving the eyeglasses on or removing them when taking a photograph. This must be your choice. While I realize that removing glasses is a nuisance (especially when you need them for reading the figures on the camera and lenses), I suggest this approach for handheld photography. For camera steadiness, the camera viewfinder must be pressed firmly against the eye and forehead, and you will have a firmer support when pressing it directly against the eye instead of the eyeglasses. I make removing my own

eyeglasses more convenient by hanging them on a chain, so they can be dropped easily. If you decide on viewing with your glasses, the eyepiece correction must be made accordingly.

The image you see in the viewfinder is also optically magnified. Therefore, eyepiece magnification should also be considered, especially on SLR cameras. A higher magnification will likely help you to focus faster and more accurately.

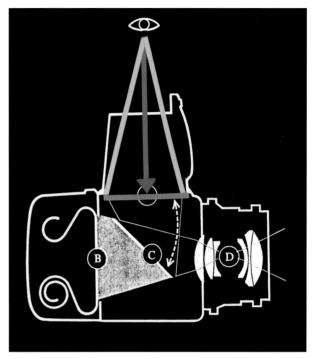

The purpose of any viewfinder, on any 35mm or medium format SLR camera, is to provide a sharp, magnified image of the focusing screen.

■ Focusing Screens

Focusing screens on SLR cameras come in plain ground-glass with a split image rangefinder, or microprism—or a combination of the two. This must be your personal choice. When deciding on a focusing screen, you should seriously evaluate both the brightness and sharpness of the image.

Brighter screens make composition easier, especially when photographing in low light, but don't necessarily make focusing faster or more accurate. For this, you need a sharp-looking image on the screen. Superb sharpness is offered on some modern screens, where the screen surface is practically invisible. It is almost like a microprism over the entire surface with the image very visibly jumping in and out of focus.

Automatic focusing works beautifully in most cameras and may actually produce sharper results for photographers who have a viewing problem. Naturally, we the photographers must always decide on what part of the subject to focus. We must be able to lock the focus and have the option for manual focusing if we do anything more serious than snapshooting.

For accurate focusing on an SLR camera, you should periodically have the mirror alignment checked by an authorized service station. This is because, on SLR cam-

eras, the mirror swings up and down every time we take a picture. For this reason, there is the possibility that the mirror does not go back to the same exact position after thousands of exposures. If so, focusing is no longer correct.

■ MOTORDRIVEN FILM ADVANCE

Motordriven film advance is an expected feature built into today's better 35mm cameras. Motordrives are also a part of many medium format cameras—if not built into the camera then available as an accessory motor winder. For most photographers, the motordrive is nothing more than a convenience, eliminating the need to advance the film manually.

Sequences. In some fields of photography—sports, for example—the main benefit of using a motordrive is fast sequence shooting. Such sequence photography offers greater possibilities for capturing an event or action at the most effective moment (naturally, at the expense of using up a lot of film). Some 35mm cameras are able to shoot several images per second, while in the medium format, the speed of shooting is reduced to about one image per second.

Camera Movement. There are other benefits to a motordrive, though. For example, sequences of images can be made without the danger of moving a mounted camera between images. This can be especially helpful in close-up work, in scientific photography and in copying.

A motordrive is very helpful when photographing people, allowing you to keep your eye in the viewfinder and maintain constant contact with the subject. This photo was taken in Mexico.

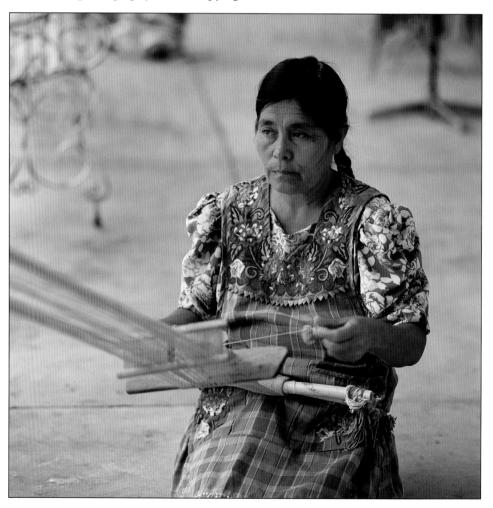

Portraits. The main benefit of the motordrive for most photographers is simply that you can keep your eye constantly in the viewfinder. Therefore, you maintain constant contact with your subject, and can press the release at the perfect moment, and avoid missing great pictures because you are not ready. Fashion photographers

will point this out as their main reason for using motordriven cameras, but it can be helpful to portrait photographers as well—especially when photographing babies and children who constantly change position and expression. Using a motordriven camera with remote release capability also allows you to work from a distance—an additional benefit. Instead of standing behind the camera, you can be next to the baby or child—making it easier to obtain the expressions that are so important in photographing children. For these applications, you do not need a camera that shoots several frames per second; about one picture per second is just right. That is about as long as it takes for a person to turn the head or body, to change expressions, or for a model to fall into a new pose.

Handheld Photography. A motordrive is equally helpful when photographing people anywhere in the world—whether candidly or when they know they are being photographed. A motordriven camera also encourages handheld photography. Whether this is good or bad

depends on the field of photography or the photographer's shooting habits. Some commercial illustrators who were pretty much tied to tripod work found new freedom, new enjoyment, and new creative opportunities working with a handheld 35mm or medium format camera. These positives can easily outweigh the negative part of the motordrive—the additional weight and bulk of the equipment.

Bracketing. A motordriven 35mm or medium format camera may also provide automatic exposure bracketing, which is helpful when you must shoot fast—in sports, for example. In most of my work, using a precise built-in spot metering system, I seldom find a need for bracketing. If I do, I prefer to do it manually. The main reason is that, when photographing people, I like to know exactly when the exposure is made. Also, my bracketing value changes from one situation to the next. Automatic bracketing, however, can be helpful in many situations where a less precise metering system is being used, and especially if one does not have a complete understanding of exposure.

Batteries. Motordrives, like other camera functions, need batteries. Usually a specific type must be used so you have no choice. When standard A, AA, or AAA types are called for, you usually have a choice of the standard alkaline, lithium or rechargeable type. While standard alkaline types serve the purpose, the more expensive lithium types last longer, give more exposures, and are more reliable in cold temperatures. It pays to spend the additional money. Always carry spare batteries for the motordrive and all the other camera functions.

A motordrive in a camera may also offer the possibility of automatic exposure bracketing, here in ½ f-stops.

CAMERA OPERATION FOR IMAGE QUALITY AND EFFECTS

Throughout the entire time the shutter is open and the exposure is being made. Contrary to some photographers' belief, achieving the ultimate image sharpness does not necessarily require a tripod. With 35mm, APS and even medium format cameras, handheld photography can create images equal in sharpness to those created using a tripod. Use your judgment, and select the approach that will produce the desired results in the most effective way without taking away the enjoyment of your photography.

The handheld approach is suggested not only when you have to work fast to capture people candidly, but also to encourage photographing from different camera

People, especially when they are engaged in activities, should be photographed without a tripod. Insisting on a tripod would make you miss some of the most wonderful picture possibilities. This photo was taken in Mexico.

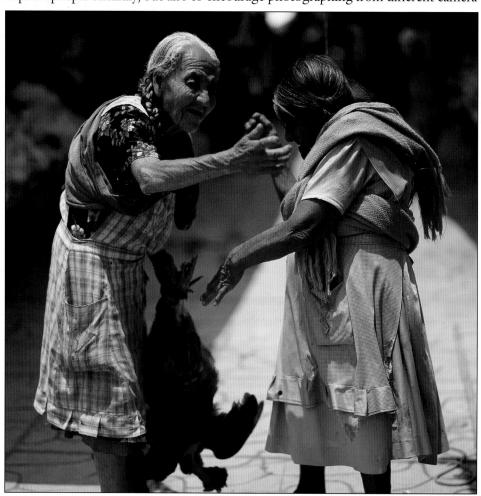

angles. It is time-consuming to set up a tripod and change tripod height. It is even more time-consuming to move the tripod around while you are investigating different camera angles. Some tripods also make it difficult to get low camera angles. As a result, tripod photographers tend to photograph everything from the same, most convenient, tripod height. If you want or need to use a tripod, I suggest that you first investigate all the possible angles and use of lenses before placing the camera on the tripod. Move around the subject with a handheld camera. View the scene from different angles and distances or through different lenses. Look at the subject from low and high camera angles. Don't set up the tripod until you have thoroughly exhausted all possibilities and found the most effective camera position. Naturally, there is also nothing wrong with photographing the subject in several different ways so you can determine later which view makes the most effective image.

The main drawback for handheld photography is that the inherent camera motion limits the choice of shutter speed, and thus the choice of aperture and depth

of field. Handheld photography also makes you more likely to select films of a higher sensitivity where the slower, somewhat sharper films could have been used with a tripod.

■ Successful Handheld Photography

Cameras can be held in many ways. Try different methods until you find one that you feel provides the greatest steadiness. You may also find that different lenses call for different approaches. For example, a camera equipped with a longer telephoto is better held differently than the same camera used with a shorter lens.

However you hold the camera, you need a firm foundation. Start by standing with your feet apart. Press your elbows into your body for additional support. To hold something (like a camera) steady, you need two forces opposing each other: one pushing one way, the other pressing in the opposite direction. This condition is obtained when the hands press the camera firmly against the eye while the forehead

pushes in the opposite direction. A firm contact between the eye and the camera eyepiece thus becomes the main determining factor for camera steadiness.

Because of this, it is recommended that you view without eyeglasses, placing the necessary eyepiece correction into the camera viewfinder. This is possible—in one way or another—on most cameras today.

■ MIRROR LOCKUP

Whenever you work from a tripod, camera, or copying stand with any SLR camera, be sure to lock up the mirror so that camera movements that might produce vibrations (such as the mirror lifting up) are performed before the exposure is made. While this so-called prereleasing is really crucial only at longer shutter speeds and with longer lenses, I make a habit of doing it at all times.

Contrary to popular belief, a medium format camera is not limited to tripod work. A compact camera makes an excellent and successful tool for handheld operation. Best camera steadiness is always achieved when the hands press the viewfinder eyepiece firmly against the eye.

■ TRIPODS

The use of a tripod is recommended when using longer lenses and/or longer shutter speeds. For example, when photographing subjects or close-ups where the point of focus must be clearly established when evaluating the image on the focusing screen; in portrait or fashion photography where directing the people is most important; when the composition must be carefully evaluated on the focusing screen; or when sequences of identical images must be produced.

Shutter Release. Most photographers' approach to tripod photography means releasing the shutter with a cable release while standing away from the tripod. This is the recommended and necessary approach when shutter speeds are longer than ½ or one second. At shorter shutter speeds, you can reduce or eliminate the danger of camera motion by doing just the opposite. Place your hands on top of the tripod or camera with your eye pressed against the viewfinder as you do for handheld photography. Lay your own weight on top of the tripod, pressing tripod and camera to

the ground. You can still use a cable release if you like, however, you really do not need it for this approach, since the tripod acts more like a supplementary support than the sole means of supporting and steadying the camera. This method of tripod photography allows you to obtain good steadiness, even with a lightweight tripod and longer lenses, something you will appreciate when traveling.

Selecting a Tripod. Maximum camera steadiness would call for the largest, heaviest studio tripod, but tripods used on location must also be carried. Therefore, you need a compromise between steadiness and portability. Such a tripod must be designed for fast, convenient operation so it is a pleasure—not a nuisance—to photograph.

An elevating extension is practical for lowering or raising the camera. The tripod, however, should bring the camera up to eye level without the need for using the extension. Do not consider the elevating extension as part of the tripod height, because the three legs of the tripod should bring the camera up to eye level. Use the center post only for minor adjustments in the camera height. A camera is

much sturdier when it sits on three legs instead of a single post.

I prefer to use a ball head, because it allows me to work faster than a head with separate adjustments and locking levers for side and front tilt. Look for a tripod coupling that also allows instant attachment and removal of the camera to/from the tripod.

Tripod Substitutes. When you feel that some camera support is necessary, before rushing for the tripod investigate other methods for steadying the camera. You may be able to lean your body, arms or head against a wall, tree, or post, or rest the camera (or your elbows) on a nearby surface. For low camera angles, lie on the ground and use your elbows as a support.

Monopod. Excellent camera steadiness can also be obtained with a monopod, which is easier to carry and quicker to set up than a tripod. The steadiest monopod operation is achieved when the foot is moved two or three feet forward with the monopod tilted toward the photographer. In a way, the monopod then forms the

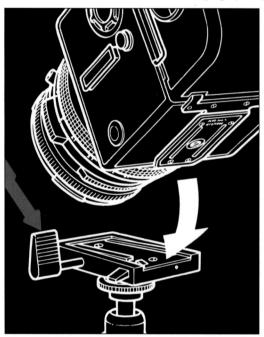

The use of a tripod coupling simplifies and speeds up photography. Such couplings can be used with most cameras. Some, however, are made for specific camera models.

third leg of a tripod with your own legs as the other two. You can obtain a steady grip with your eye pressed against the viewfinder, elbows pressed against your body, and either both hands on the camera or one hand on the camera and the other on top of the monopod.

■ SELECTION AND USE OF SHUTTER SPEED

On automatic cameras, you can let the electronics in the camera decide on the shutter speed for you. This will, in many cases, produce an acceptable picture for you. For serious work, however, you also want to maintain control over the shutter speed. You need not necessarily set the speed manually, but you want to know what the set shutter speed is before you press the release. In many cases, you may then want to change the aperture/shutter speed combination. Another option you have on many cameras is to preset the shutter speed. Whatever the option, you should know at what shutter speed the image will be made.

With a tripod-mounted camera, basically any shutter speed is usable. In handheld work, however, you want a speed that is short enough to reduce or eliminate the danger of unsharpness due to camera motion. This means that shutter speed must be the first consideration in handheld work, while selecting the aperture for correct exposure is the second. This is the reverse process from working with a tripod, when selecting the aperture that produces the desired depth of field comes first.

The longest usable speed depends on your camera, your ability to hold a camera steady, whether the air is calm or the wind makes holding difficult and the focal length of the lens. A good rule that works for many photographers is to keep the shutter speed at or shorter than the inverse of the focal length of the lens. For example, you might shoot at ½50 second or ½60 second (or shorter) when using a 50mm or 60mm lens, and at ½250 second when you use a 250mm lens. Due to the high resolution of today's films, I suggest shortening the speed even further, to ½100 or ½125 for a 50mm or 60mm lens—especially on a medium format camera where you want to be assured of the utmost image sharpness. I also suggest being more careful when handholding longer focal length lenses at any speed.

Photographing Motion. When photographing moving subjects, the shutter is again the first consideration. You have a choice of selecting a speed that either freezes or blurs the motion. When you freeze the action, you create an image as we see the world with our eyes. With a longer speed that blurs the action, you not only convey in the image the feeling of motion, but you create something that is different from the way we see the world—something that we cannot see with our eyes. I feel this is the reason why blurred motion images can be so beautiful and interesting. In a way, the shutter speed is perhaps the greatest feature that we have on every camera, since it records a moving subject as only a camera can do. This applies not only to the typical moving subjects, such as water and sports action, but to anything that moves—leaves on a tree or grasses in a field moving in the wind, rides in an amusement park, reflections on water.

The amount of blur created by a certain shutter speed cannot be seen in the viewfinder of any camera. It can only be seen once it is recorded on the film. You must either photograph the subject at different shutter speeds and then evaluate

WITH A

TRIPOD-MOUNTED

CAMERA,

BASICALLY

ANY SHUTTER

SPEED

IS USABLE.

the results on the film, or make test exposures on Polaroid film (if possible). Blurred motion is one application where the possibility of using a Polaroid back on a medium format camera has a definite advantage.

To emphasize motion further, you may move the camera—an approach that also works beautifully in combination with a moving subject. This is a common approach in car, horse or track and field races, where the camera follows the moving subject while making the exposure. The result is that the main blur is in the background, which emphasizes the motion and the speed. To make this clearly visible, you need a background with details, with a contrast of light and dark colors. A plain background, such as the sky, does not work. While common in sports, this approach is not limited to that subject alone. It works with any moving subject—a bird in flight, a child running through a field of tall grasses. The motion is frequently emphasized when parts of the subject are moving in different directions (the arms and legs in a runner or cyclist, the moving wings of a bird, etc.).

Blurred motion effects are not limited to streams and waterfalls. Anything that moves (such as leaves blown by the wind) can make a fascinating image.

6

LENSES FOR CREATING THE ULTIMATE SHARPNESS

Since Lenses create the image and are a main determining factor for image quality, it is to your advantage to know something about lens design and manufacturing, lens types, and image creating characteristics of lenses. This is especially true since there are many advertising claims that are confusing, and even misleading, to someone not familiar with optics. The sharpness of any lens made anywhere in the world depends on two main factors: the lens design, and the accuracy and precision of the manufacturing. The latter is the main difference between ordinary and quality lenses. Furthermore, the precision in assembling the elements into the lens barrel and the mechanical construction of the lens barrel are determining factors for the lens performance.

■ Lens Design

All lenses are computer designed, which means nothing more than that a computer traces the light rays of the different colors through the different lens elements instead of a person doing it on paper. The computer does not design the lens, it only makes the calculations. What comes out depends on the information put into the computer by the lens designer.

For example, many different types of glass are available to the designer today, including the highly promoted low dispersion types. However, the use of such glass does not automatically produce a better lens. It is the lens designer who must decide whether the use of such glass is beneficial.

Some lenses are also promoted through the use of aspheric lens elements. Such elements, which are difficult to produce, again, do not necessarily produce a better lens. A lens designer may find a solution to produce a lens of equal quality in other ways.

Even the number of lens elements is not a determining factor. There are always more lens elements in a lens of larger aperture, since it is more difficult to reduce all lens aberrations (faults) over the entire image area as the lens aperture increases. You are likely finding more elements in a wide-angle lens, as the larger area coverage makes it more difficult to achieve corner-to-corner quality. But in any type of lens, a good lens designer may come up with a better lens with fewer elements by applying the latest design techniques and using the latest types of glass. Only a lens test can reveal the lens performance.

THE SHARPNESS

OF ANY LENS

MADE ANYWHERE

IN THE WORLD

DEPENDS ON

TWO MAIN

FACTORS...

■ APOCHROMATIC LENSES

Camera lenses are corrected mainly for the blue and red colors of the spectrum. If well designed, such lenses produce superb image sharpness even on today's high resolution films. However, such lenses in the long focal length types may produce a color fringe, or a slight unsharpness in black & white on a sharp dividing line between bright and dark colors. This effect is seldom noticeable and practically never objectionable on a lens made by a well-known, reputable manufacturer. Apochromatic types, on the other hand, are corrected not only for blue and red, but green as well—which can be beneficial, at least in long telephoto lenses. Still, as always, the quality of any lens depends on who designs it and who makes and assembles the lens elements. An additional distinction: apochromatic lenses normally have some lens elements made from fluoride rather than glass. Because the focus setting of these lenses depends on the temperature of the air, the focusing ring may turn beyond the infinity setting. Always focus such a lens visually on the focusing screen.

■ WIDE-ANGLE DESIGN

Wide-angle lenses on large format cameras and non-SLR 35mm/medium format cameras can be (and usually are) of a true optical design. They are therefore the best

for wide-angle photography at far and close distances.

However, since this lens design requires that the rear lens element is close to the film plane, such lenses cannot be used on SLR cameras. This is because the mirror that moves between the lens and film requires a long back focus. This can only be obtained on another wide-angle lens design known as retrofocus. All wide-angle lenses on SLR cameras are, therefore, of this design. While they probably have somewhat more distortion, they can provide excellent quality—at least at long distances where wide angles are usually used. They are not, however, the best types of lenses for close-up photography unless they have floating lens elements. In such a design, some lens elements are (or can be) moved separately to improve image sharpness

at closer distances. Since all floating lens element types are of a more recent design, they will likely also produce better quality at longer distances.

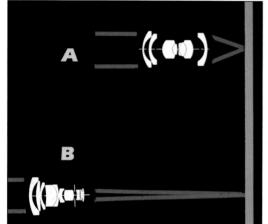

In an optically true wide-angle design (A), the rear lens element is close to the film. Such lenses are therefore found only on rangefinder, large format and cameras with an optical viewfinder, not the SLR type. Wide-angle lenses on SLR cameras need the long distance between the film and rear element and must be of the so-called retrofocus design (B).

■ ZOOM LENSES

Until recently, the general assumption was that a zoom lens does not produce the image sharpness of a fixed focal length type. Even today, it can be said that there is no zoom lens that produces the sharpness of a fixed lens at every focal length over the entire zoom range. Still, many of today's zooms produce excellent quality that is completely satisfactory for many applications. Only a film test will tell. When you make such a test, you must make it at different focal lengths.

The main distinguishing factor among zoom lenses is the zoom range—the ratio between the shortest and longest focal length. On medium format cameras, the range is limited for physical reasons. Zoom lenses for 35mm cameras can go from a wide angle to a long telephoto, usually associated with a change of maximum aperture. While no general statement can be made, a lens with a shorter zoom range

may be preferable from a quality point of view. It is unquestionably more difficult to maintain good quality over a longer zoom range. Check published quality figures.

QUALITY AT DIFFERENT DISTANCES

A lens designer must decide at what distance each lens should produce the very best image quality. The differences in quality at different distances depends on the lens design. It is hardly noticeable on an optically true wide-angle design, but more obvious on the retrofocus type without floating lens elements. Macro lenses that focus down to inches are available for many cameras. Their quality is undoubtedly good in close-up photography, but it should also be acceptable over the entire focusing range. If close-up photography is not your field, you may be better off with the non-macro type. If close-up photography is your field, though, you may also note that some manufacturers have lenses that are specifically designed to provide the best image sharpness at close distances.

■ MTF DIAGRAMS

The quality of lenses used to be expressed in resolution, or the lines per millimeter that were recorded separately on the image. Photographic engineers and scientists, however, have found that the sharpness of an image as perceived by our eyes is determined more by the sharpness of the line edges than the resolution in number of lines. The modern way to publish the data for the lenses is in so-called MTF diagrams. These diagrams combine resolution with edge sharpness.

Some lens manufacturers publish such data. There are, however, no standards among manufacturers. Some manufacturers show the curves that the computer produced. Other lens manufacturers provide the results that are actually produced by

THE DIFFERENCES

IN QUALITY

AT DIFFERENT

DISTANCES

DEPENDS

ON THE LENS

DESIGN.

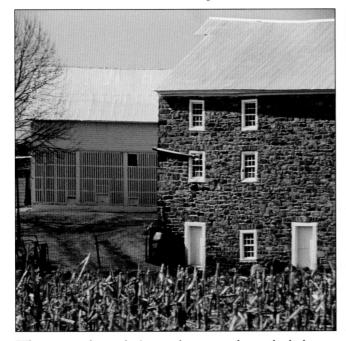

When you evaluate the image sharpness, always check the center and corners. The photo on the left is what you see when evaluating the original image (right) with a 10x magnifying glass. This quality is excellent with the lens aperture wide open—especially considering that the enlarged portion is at the very edge of the original image. Taken with a 6cm x 6cm medium format camera.

the finished lens. This nonstandardized practice makes it difficult or impossible to compare lenses made by different manufacturers. The curves, however, indicate the sharpness difference between the center of the image and the edges with a specific lens, or (if the diagrams are published for different apertures) the sharpness improvement when the aperture is closed. These curves can also show the sharpness differences between close and far distances, if published for both distances.

■ Multi-Coating and Lens Shades

REGARDLESS

OF YOUR

EQUIPMENT,

USE THE BEST

POSSIBLE SHADE

ON EVERY

ONE OF

YOUR LENSES.

All modern lenses are multi-coated to reduce lens flare and to increase the contrast and color saturation in the images. To what extent the coating reduces flare, however, depends completely on the lens design and varies from one lens to another. Multi-coating does *not* eliminate or reduce the need for using lens shades for one reason: multi-coating and shades serve different purposes. The multi-coating is there to help reduce reflections from the light that goes through the lens to create the image. The shade is there to eliminate light that is not needed for creating the image from entering the lens in the first place.

Regardless of your equipment, use the best possible shade on every one of your lenses. For some cameras, you can select bellows shades, where the bellows can be extended more or less to match the focal length of the lens. Made from a folded bellows, they usually provide the best shading.

Using the most effective shade is essential not only when photographing toward the sun or other light source, but also on overcast days when white skies are very bright, when photographing in the snow, sand, or near water and especially when photographing against white backgrounds in the studio. Light can also be reflected onto the film from the camera interior, a reason some manufacturers coat the interior with a dull, dark finish.

ILLUMINATION

A photographer's main concern is image sharpness. A second concern must be image brightness. On standard and longer focal length lenses, image brightness is usually fairly even from center to corner. Wide-angle lenses, however, frequently show a darkening in the corners that can be objectionable in many pictures—especially those that have large areas of equal brightness, such as a sky. Some lens manufacturers publish the illumination data. If not, test wide-angle lenses for image brightness. It is worth noting that the darkening in the corners with extreme wide-angle lenses is not caused by the lens design, but the simple fact that the aperture opening through which the light must go is a smaller elliptical size for light rays that enter at a steep angle, while it is a full circle for light that enters from the front. By the use of central gray filters, the image brightness is evened out on wide-angle lenses for large format or panoramic cameras. However, since they reduce the light that enters from the front, exposure must be increased.

■ IMAGE DISTORTION

Distortion is the lens's ability or inability to record straight lines as straight lines over the entire film area. Straight lines near the edges that appear curved inward are referred to as "pincushion distortion"; if curved outward we call it "barrel distortion." Distortion needs to be considered mainly when photographing buildings and products.

Wide-Angle Distortion. Images taken with wide-angle lenses on any camera often show a distortion in subjects on the edges or corners of the picture. People's faces look distorted, a round chandelier in the corner is egg-shaped. This so-called wide-angle distortion happens when photographing a three-dimensional subject with any camera and wide-angle lens. The distortion, however, is not caused by the lens. It must be blamed on the film plane being flat in the camera, thus "stretching out" such three-dimensional subjects at the sides or corners. It cannot be avoided, regardless of the camera or wide-angle lens you are using. Try to improve the picture by changing the composition so that such subjects do not appear at the edges or corners.

Besides the flat film plane, there is a second reason that aggravates this distortion of three-dimensional subjects. The wide-angle lens sees the subject in the center from a different angle than the subjects at the edges. In a group picture, the lens looks at the front of the faces of the people in the center, but at the side of their heads of those standing on the left or right. You can reduce the distortion by turning the people so they all look straight toward the lens, so the lens "sees" the front of the face of everyone in the group. The same approach can be used in a lineup of

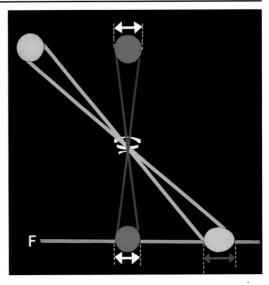

Three-dimensional subjects at the edges of the frame appear elongated on the flat image plane. The effect is most obvious with wide-angle lenses and appears even in pictures taken with the best quality, distortion-free lenses.

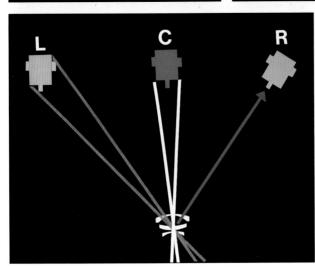

The photo on the left (above) shows the subject as it appears in the center on the film. The photo in the middle (above) shows the subject on the side, taken with a 50mm lens (equivalent to 32mm on 35mm) on a medium format camera. Notice the distortion. The photo on the right (above) is the same subject at the side taken with the same lens, but the head is turned toward the camera lens. Distortion is barely visible. The diagram on the left illustrates how wide-angle distortion is further emphasized because the lens sees subjects at the edges differently from those in the center. The lens looks at the side of a person's head on the left (L), not the front of the face as in the center (C). The distortion can be reduced by turning the subject so the lens looks at the front of their face (R).

With wide-angle lenses, objects close to the edges or corners appear distorted. It is not a fault of the lens and happens on any camera with any wide-angle lens.

products. Since wide-angle distortion is not the fault of the lens, it does not occur when photographing flat, two-dimensional subjects—in copying, for example.

■ TELECONVERTERS

Teleconverters come mainly in two types (2x and 1.4x), and are mounted between the camera and lens. A 2x extender doubles the focal length of any lens (creating, for example, a 500mm focal length when combined with a lens of 250mm focal length). A 1.4 extender lengthens the focal length by 1.4x.

While some teleconverters are, for optical or mechanical reasons, designed for specific lenses, most are designed to work with all focal length lenses in a camera system. However, since the various focal length lenses have different lens designs, there must naturally be a compromise. The image sharpness will undoubtedly vary somewhat, depending on the lens with which the teleconverter is combined. Today, however, we have teleconverters that produce excellent quality, so they no longer need to be considered the "poor man's choice for a telephoto lens." Such converters may have as many—or even more—lens elements than some prime lenses and can be made to the same quality standards. Consequently, they cost as much, or almost as much, as a prime lens. Even if a teleconverter costs as much, you still have

...MOST

ARE DESIGNED

TO WORK WITH

ALL FOCAL LENGTH

LENSES IN A

CAMERA

SYSTEM.

Image quality with a 1.4x tele-extender.

the benefit of being able to combine it with different focal length lenses and obtaining long focal lengths without having to carry the heavier telephoto lenses.

Of course, a teleconverter can only produce good image quality when it is combined with a high quality lens, since the teleconverter emphasizes the faults of the

Image quality with a 2x teleextender used in this photograph taken in Norway.

basic lens. Tele-extenders also create a loss of light equivalent to two f-stops with a 2x extender. When combined with a lens with an f/2.8 aperture, the combination of lens and 2x extender will have a maximum aperture of f/5.6. From a photographic point of view, the loss of light is frequently only one f-stop, as longer focal length lenses also tend to be slower. As an example, a 120mm lens may be f/4 resulting in a 240mm f/8 lens when combined with the 2x extender. A 250mm lens, on the other hand, may have a maximum aperture of f/5.6. A 1.4x extender loses one f-stop.

Teleconverters also have a very valuable advantage: the focusing range of the lens is maintained. If, for example, a 180mm lens focuses down to five feet, it still focuses down to five feet when combined with the teleconverter. With a 2x converter on the 180mm lens, the result is a 360mm focal

length lens focusing down to five feet—which may very well be much closer than the minimum focusing distance on a longer telephoto.

The depth of field scale on the 180mm lens no longer applies, since the depth of field is now equivalent to that of a 360mm lens. On the other hand, the shooting aperture is two f-stops less than set on the lens; f/11 with the lens set at f/5.6. The depth of field at 360mm and f/11 happens to be very similar to the depth of field at 180mm and f/5.6. For all practical purposes, then, you can use the depth of field scale on the lens (180mm in this example) for the aperture that is set on the lens (f/5.6 in this case).

7 EFFECTIVE USE OF LENSES AND LENS CONTROLS

A PERTURE AND FOCUSING ARE THE TWO MAIN OPERATING CONTROLS ON A LENS. Shutter speed is the third if the lens has a shutter—otherwise this control is part of the camera.

■ Choice of Lens Aperture

Image sharpness improves somewhat, especially on the edges, as the aperture is closed down. Even with the aperture wide open, the loss of sharpness should never be objectionable or even noticeable under normal viewing conditions of the final print or transparency. If it is, buy a better lens. It should also never be necessary to close the lens aperture more than two f-stops to have good sharpness, even on the edges and when viewing the original under a 10x magnifying glass. Top quality lenses can give you such results with the lens aperture wide open in applications for which the lenses are designed. In any case, it should almost never be necessary to close down the aperture simply for the purpose of obtaining satisfactory corner-to-corner quality. The one exception is on large format camera lenses, which are designed to produce the best image quality at small apertures, usually at f/22.

■ IMAGE SHARPNESS AT SMALL APERTURES

When light goes through a very small opening, some of the light rays are refracted. This happens even in a pinhole camera. That phenomenon explains the frequently

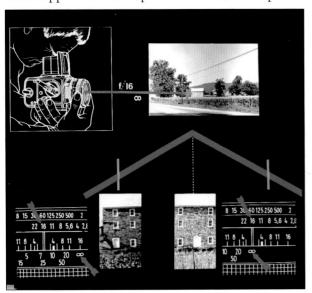

Only the subject on which the lens is focused (the stone building at infinity in the graphic illustration at the left) has maximum sharpness. There is a visible loss of sharpness in subjects closer or farther from the camera, even if they are within the depth of field range. When the lens is focused so the building is close to the end of the depth of field scale (infinity mark set opposite f-16 on the depth of field scale) the building is outright blurred under a magnifying glass (bottom right).

Left—When different focal length lenses are used from the same distance, the wide-angle (WA) has more depth of field than the standard (S) or telephoto (T). Each lens, however, also covers a different area, creating a completely different image.

Right—When the lenses are used to cover the same area, all lenses have the same depth of field at the same aperture.

heard statement that the lens aperture should never be closed completely. However, while this is theoretically correct, it need not be considered with high quality lenses made by a reputable manufacturer. Such manufacturers limit the minimum aperture to a point where the light refraction does not create a visible loss of sharpness. That explains why such lenses may only close down to f/16 or f/22.

If you need to close the lens aperture completely on such a lens to obtain the desired depth of field, close it. You may decide on the lens aperture mainly based on the desired shutter speed (in handheld work, for example) but for the majority of pictures, the choice should be based on the desired depth of field. This can be obtained from the engraved scales on the lens or from charts.

When a lens is set to a certain distance, only the subject point at that distance is

recorded critically sharp in the camera. Anything closer or farther is progressively less sharp. There is, however, a range in front and beyond the set distance where subjects

are recorded with acceptable sharpness. This means that they will still appear sharp

On today's high resolution films, you will see the loss of sharpness within the

■ Depth of Field

ANYTHING CLOSER OR FARTHER IS

PROGRESSIVELY

LESS

given depth of field range when you examine the original under a 10x magnifying glass—especially on the larger medium format originals. Subjects close to the limit of the given depth of field range appear outright unsharp under the magnifier. This is, in part, because depth of field charts were calculated years ago when films were SHARP.

to our eyes if the negative or transparency is enlarged to an "ordinary" size.

not that great and, as far as I know, they have never been updated.

If you do critical work on today's high resolution films, I suggest that you do not use the entire depth of field range, or that you stop the lens aperture down at least one more *f*-stop than is necessary to cover the desired range. If a specific part within your scene (the mountains in the distance, for example) is to be recorded with the utmost sharpness, set the focusing ring at that distance; don't rely on depth of field.

Depth of field is a calculated figure and is not related to the lens design or lens performance. However, a lens that is critically sharp may, perhaps, appear to have less depth of field. That is only because the falloff in the sharpness is more obvious on such a lens. A frequent statement is that telephoto lenses have less depth of field than those of shorter focal length. This is correct when the different lenses are used to photograph a subject or scene from the same distance. If used this way, however, the wide-angle lens covers a much larger area than the standard or telephoto lens. The lenses create completely different images. If different focal length lenses are used to cover the same area (i.e., with the wide-angle closer to the subject and the telephoto farther away), all lenses produce the same depth of field at the same aperture. Keep this in mind—especially when you photograph a subject of a specific size (a portrait, for example) or in close-up or product photography.

Regardless of the lens or close-up accessory, the range of sharpness is the same. When using a longer lens, however, the falloff in sharpness beyond the depth of field is more obvious than with a shorter focal length, so you have a chance to blur the background more or less.

Composing Group Pictures. Some photographers seem to be under the impression that the people in a group picture should be arranged on a curved rather than a straight line, especially when wide-angle lenses are used. The reasoning is that the

DEPTH OF FIELD

IS A CALCULATED

FIGURE AND IS NOT

RELATED TO THE

LENS DESIGN OR

LENS PERFORMANCE.

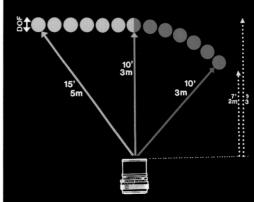

For maximum sharpness, the objects or people must be in a straight line (as shown in the photo on the left), even though the people at the edge are farther (fifteen feet) from the lens. The people can be lined up in a curved plane, but the aperture of the lens must then be reduced to produce more depth of field (from seven to ten feet in the diagram above).

people on the outside are farther from the lens than those in the center (perhaps fifteen feet from the lens, instead of the ten feet between center subjects and the lens). Arranged on a curved line, everyone can be the same distance from the lens and will therefore be sharp.

However, this is not correct as far as sharpness is concerned. Every lens is designed to produce a sharp image on the flat image plane, from any flat subject in front of the lens, whether it is the flat wall of a building, the text arranged on a flat copy board, or a group of people. For best edge-to-edge sharpness, align the people on a flat plane. You can perhaps align the people in a circle for better flash illumination. However, if so, you must close the lens aperture to provide the necessary depth of field—from seven to ten feet in the aforementioned example.

Hyperfocal Distance. Hyperfocal distance is related to depth of field and is usually described as the focus setting that produces the maximum depth of field.

Hyperfocal distance is the distance setting that produces depth of field up to infinity at the set lens aperture. A lens is set to the hyperfocal distance when the infinity mark on the focusing ring is set opposite the aperture marking on the depth of field scale that corresponds to the aperture set on the lens. The hyperfocal distance is the reading that is opposite the index.

Since most lenses have engraved depth of field scales, it is not necessary to have hyperfocal distance charts. The minimum depth of field distance is opposite the corresponding aperture marking to the left of the index. While this setting produces the maximum depth of field and depth of field to infinity, keep in mind that subjects at infinity will be acceptably, but not critically sharp.

Infiniti 8 1 2 4 8 15 30 60 125 250 500 2 3 4 22) 16 11 8 4.5 4.5 8 11 16 20 06 0.7 0.8 1 1.2 2 3 6 ∞ 2 25 3 4 6 10 20 8 1 2 4 8 10 30 60 125 250 500 2 3 4 22 16 (1) 8 5.6 4.5 1111 22 16 (1) 8 5.6 4.5 1111 22 16 (1) 8 4.5 4.5 8(1) 16 22 03 1 1.2 2 3 6 ∞ 5 3 4 6 10 20

A lens is set to the hyperfocal distance when the infinity mark on the focusing ring is set opposite the aperture marking on the depth of field scale that corresponds to the aperture set on the lens (f/22 on top, f/11 at the bottom). The hyperfocal distance is the distance opposite the index mark.

■ Focus

Plane of Focus. The range of sharpness in a photographic image can also be changed by tilting the lens or image plane in relation to the other.

This is a well-known practice in large format photography, where it is usually done by tilting the lens plane. Some shift lenses also allow tilting, thus offering this capability in 35mm. In the medium format, the possibility exists either with a flexible bellows between camera body and lens, or with a special camera body that features a flexible bellows between the lens and film frame (like a view camera).

This tilt control allows more sharpness from front to back (or left to right) without changing the lens aperture. The principle is well-known to large format photographers: you have the maximum range of sharpness when the lines extended from the film plane and the lens plane meet at a common point on a line extended from the subject plane.

This control, however, is possible only in one plane, and in a flat plane only. If an object protrudes above this plane (a tree trunk, a house, a tall vase in a still life), the protruding object must be kept in sharp focus with the lens's depth of field, closing down the aperture to keep that object within the range of sharpness.

Without such a special camera or lens, you can take advantage of this concept in a limited fashion. On a normal camera, the plane of focus is parallel to the image

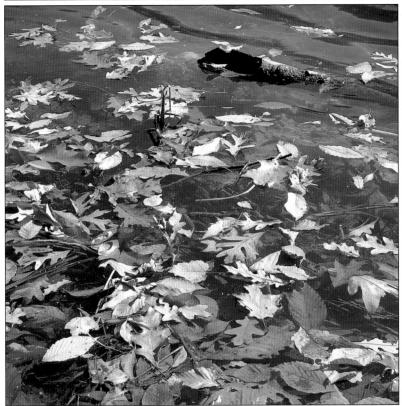

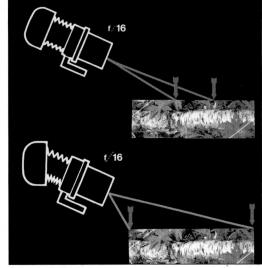

The range of sharpness is usually determined by the depth of field, which depends on the lens's aperture setting (top). By tilting the image plane in relation to the lens plane, the range of sharpness can be extended at the same aperture (bottom). The picture on the left was made with a moderate telephoto lens, with the lens aperture fully open.

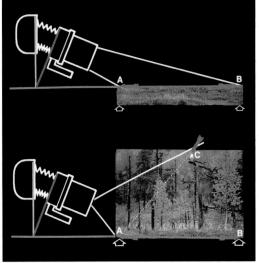

When tilting the image/lens plane, the sharpness range can be increased along one plane only. If tilted along plane A-B (top), a subject at C (bottom) will not be sharp unless it is within the depth of field range of the lens. You could also shift the image/lens plane along the A-C axis, but then B would be out of focus. In the picture on the left, the film plane was tilted for sharpness on the pumpkin in the foreground and the faces in the back. The lens aperture was closed down to maintain sharpness on the pumpkins in front of the figures.

plane. Rather than photographing a flat landscape straight on when the plane of focus (the image plane) is 90° to the subject plane, try to do it from a higher angle, and angle the camera downward. This brings the image plane more parallel to the plane of the landscape.

35mm and now medium format cameras, is well acknowledged in casual photography. It is also useful in applications where there is little time for camera adjustments, or with moving subjects (such as in sports and wildlife photography). The automatic focusing feature need not be ignored even for critical and serious photography, as long as it offers a single focus mode that allows you to focus on the part of the subject you choose, then lock the focus setting so you can recompose without it changing. In serious photography, the photographer, not the camera, must decide which part of the subject or scene needs maximum sharpness. The benefit to you of the automation may simply be in the fact that the camera turns the focusing ring instead of you doing it manually. However, the camera may also focus more accurately—a feature that is especially beneficial for photographers who have

Automatic Focusing. The benefits of automatic focusing, a common feature in problems seeing a sharp image in the viewfinder of the camera.

In many pictures the lens must be focused at a specific part of the scene, so an automatic focusing system must give you the option to select that area. This can be especially helpful with telephoto lenses. In this photo, a 350mm lens was used.

THE AUTOMATIC FEATURE NEED NOT BE IGNORED EVEN FOR CRITICAL AND SERIOUS PHOTOGRAPHY.

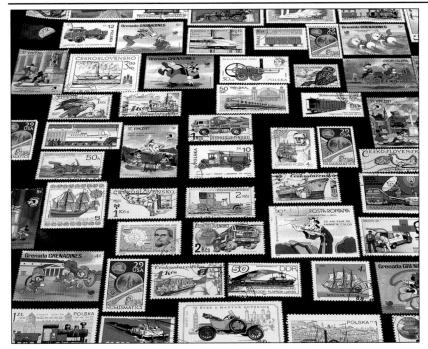

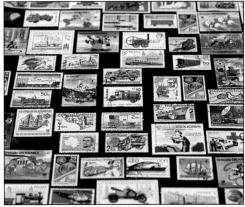

The image above was photographed at f/8 with a short telephoto lens. The image on the left was photographed with the same lens at the same aperture but with the image plane tilted to maintain the sharpness from top to bottom.

■ Manual Stop Down Control

For serious photography, the lenses on your SLR camera must have a manual stop down control. This control will allow you to see on the focusing screen how the image will be recorded on the film at the set aperture, or to decide on a specific aperture by evaluating the image on the screen. Some instructional material will tell you that the control allows you to see the amount of depth of field. I disagree. As already explained, the acceptable sharpness within the depth of field range is based on a certain degree of enlargement.

On the camera, you are looking at a small focusing screen: 24mm x 36mm in the 35mm format, or 55mm x 55mm on a square medium format camera. You are also viewing the image on a screen, which does not allow you to see the finest details and thus determine whether sharpness on a larger print will be acceptable. When the aperture is closed down, you reduce the image brightness, which makes the situation still worse. To determine depth of field, I suggest that you consult the depth of field scales.

The manual stop down control will give you a very good idea of how much sharpness or unsharpness is created in the fore- or background, revealing disturbing fore- or background elements that may go unnoticed at the maximum aperture. Since backgrounds are an important part of many of our images, this fact alone justifies using the stop down control for evaluating our images on the focusing screen. In short, the manual stop down control gives you a very clear idea of what the final image will look like without having to record it on film.

A medium or large format camera has a distinct advantage over 35mm as far as image evaluation is concerned. The larger focusing screen allows for better and more effective image evaluation with the aperture wide open or closed down—and on some cameras you can also evaluate the image with both eyes open, using the standard focusing hood.

To determine

DEPTH OF FIELD,

I SUGGEST THAT

YOU CONSULT

THE DEPTH OF FIELD

SCALES.

■ BACKGROUND AND FOREGROUND SHARPNESS

While the actual depth of field is the same with any lens when covering the same area, longer lenses magnify the background area and thus also magnify the degree of background unsharpness. With a shorter focal length lens, the background may be only slightly blurred. The same applies to foregrounds beyond the depth of field.

You can often produce effective images outdoors by planning the composition around completely blurred foreground objects—flowers, leaves, grasses. This works especially well in color photography, where the foreground can add an effective touch of color surrounding the main subject (in a portrait, for example). Out of focus foregrounds are usually best when blurred completely so they are not even recognizable. If the foreground is blurred just a little, it might look like a mistake. If the standard lens does not provide enough blur, go to a telephoto.

■ ZOOM LENSES AND ZOOM EFFECTS

Everything described about the use of different focal length lenses also applies to zooms. Zoom lenses simply give you the possibility of obtaining the different focal lengths by using the zoom control. On a true zoom lens, the image stays in focus while zooming. On a high-quality zoom lens without focus shift, I recommend that you always do the visual focusing on the screen with the lens set to the longest focal length. The image is more magnified, so focusing is more accurate and faster. Once focused, you can take the picture at whatever focal length gives you the desired composition.

Zoom lenses also give you the opportunity to create zoom effects by changing the focal length—moving the zoom control while the shutter is open. Changing the focal length changes the image size, thus creating the typical zoom image with streaks—something that can only be created with the camera, not with our eyes. You need a fairly long shutter speed that gives you enough time to move the zoom control while the shutter is open (I usually use ½ or one second).

When zooming from the shorter to the longer focal lengths, the resulting streaks go from the center to the outside of the image. You can make them go from the outside to the center by zooming the opposite direction. The effect also depends on whether you zoom fast or slow and whether you zoom during the entire exposure time or only part of it. Zooming over the entire exposure time, one second perhaps, mainly creates a blur. Most images are made more effective by leaving the lens at one focal length for about half the exposure (½ second) with a one-second exposure time, and zooming only over the remaining time (the remaining ½ second). This approach produces a sharp image of the subject with the streaks added and surrounding it. Zoom effects are most successful with contrasty subjects—lighted signs, highlights on water surfaces, street or car lights. The streaks produced by the highlights are best visible when they cross a darker area.

■ Lenses for Area Coverage and Perspective Control

Area coverage is the main difference between lenses of different focal lengths. From the same camera position, wide-angle lenses cover a larger area than standard lenses, while telephoto lenses cover less. A lens that has twice the focal length covers an area

ZOOM LENSES

ALSO GIVE YOU

THE OPPORTUNITY

TO CREATE

ZOOM EFFECTS

BY CHANGING

THE FOCAL

LENGTH.

Changing the focal length on a zoom lens while the shutter is open produces unique and dramatic images. The photo was taken with a one-second exposure.

half as wide and high on the same film format. Area coverage is frequently the only reason to select a specific focal length.

Two points to remember: the focal length of a lens is a fixed value, and it can only be changed by adding or taking away lens elements, or moving lens elements. That means the focal length is the same, regardless of what film format is being used. An 80mm lens from a medium format camera is still an 80mm lens when used on a 35mm camera or on an enlarger. However, lenses are also designed to cover a certain film area. This is known as covering power. 35mm lenses are basically designed to cover the 24mm x 36mm frame area and do not usually produce satisfactory image quality and illumination if put on a medium format camera. A lens designed for a larger format should, however, work beautifully for a smaller format (using only the center area of the image provided by the lens). That is why adapters are available that allow some medium format lenses to be used on some 35mm cameras.

Camera to subject distance determines perspective. With a shorter focal length lens, background subjects appear smaller and thus farther away. The background can be made to appear larger and closer by using a longer focal length lens from a longer distance to maintain the size of the foreground subject, the stop sign. The photo to the left was taken with a wide-angle lens, the middle photo was taken with a standard lens and the photo to the right was taken with a telephoto lens.

Image Perspective. Perspective is the size relationship between subjects close to and far from the camera. With our eyes, we see the world in one specific perspective we call "normal." Pictures taken with a normal (standard) lens on a camera (50mm on a 35mm camera, 80mm on a 6cm x 6cm medium format camera) show the world pretty much as we see it with our eyes. That is why it is called "standard."

By switching to a wide-angle lens and, at the same time, moving closer to the foreground subject, we can record the foreground at the same size as with the normal lens. The background subjects, however, are now recorded smaller and appear farther away. By switching lenses, we have changed the size relationship, changed the perspective. We no longer recorded a "normal" image as we see it with our eyes. We can also maintain the foreground subject size by photographing with a longer focal length lens from a longer distance. The background subjects now appear larger and closer to the camera. The mountains in the background can be made three or four times larger, making them more dominant and more dramatic. Use the standard lens to create an image as our eyes perceive it. Use the shorter and longer lenses to create an image as only the camera can.

The explanation of the use of lenses probably gives the impression that perspective is determined by the focal length of the lens. Not so. It is determined by the distance to the foreground subject. But you need the wide-angle lens to cover the foreground subject from a short distance, a telephoto to do the same from a longer distance.

Background Coverage. With a shorter focal length lens, you not only record foreground subjects smaller but also cover a larger background area. With a longer focal length lens, you cover a smaller background area. Keep this in mind, because backgrounds are an important part in many of our images. How much we cover may very well determine the effectiveness of our images. For this reason, wide-angle lenses have become popular in outdoor portrait photography. The larger background area reveals the location, making it an important part of the image. I call this a "true location portrait." Equally beneficial, longer focal length lenses allow the elimination of distracting background elements like cars, billboards, people, etc. With a longer lens, just a slight change in the camera angle can bring a completely different background area into view behind the main subject.

WITH A LONGER

FOCAL LENGTH LENS,

YOU COVER

A SMALLER

BACKGROUND

AREA.

■ EFFECTIVE **W**IDE-**A**NGLE **P**HOTOGRAPHY

Wide-angle lenses can be used to cover more of the subject or scene. When doing this, however, also try to accomplish something else—enhancing the three-dimensional aspect of the scene. You can do this by including effective foreground elements in the composition. The foreground subject can be anything—a rock or rock formation, flowers, weeds, a tree stump, a fence, etc. Such a composition

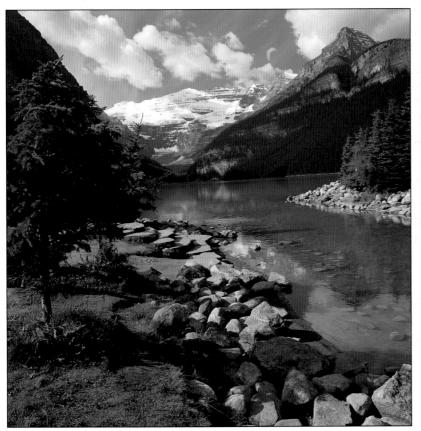

Wide-angle lenses can be effective for close-ups (above) because of the large background coverage that makes the surrounding area a part of the image. Wide-angle lenses should be used not just to cover larger areas, but to enhance the perspective, the depth, and, the three-dimensional aspect of the image (left). Including dominant foreground subjects can accomplish this.

emphasizes the use of wide-angle lenses, adds depth and a three dimensional feeling to the image, producing a true wide-angle image—the best and main reason for considering the use of a wide-angle lens.

■ FISHEYE PHOTOGRAPHY

Fisheye lenses provide an additional opportunity for creating images that are different from the way we see the world. The diagonal angle of view of such lenses is much greater (usually 180°) and completely unrelated to the vertical and horizontal coverage, regardless of their focal length. They cover a much larger area diagonally than wide-angle lenses of the same focal length. Consequently, they produce images with curved horizontal and vertical lines off the center area. This is what gives fisheye images their particular touch.

There are two completely different types of fisheye lens designs. One type produces a circular image, covering only the center portion of the film frame. The attention is created by the circular shape of the image, which becomes monotonous quickly. Such lenses are of limited value in serious photography. The other type is a full-frame fisheye, which covers the entire film area. These can be great tools for creating unusual images of ordinary subjects.

Fisheye and Non-Fisheye Images. A good full-frame fisheye lens can cover the entire film area with excellent sharpness and illumination. The typical curved lines

A full-frame fisheye lens can produce images that do not have the typical fisheye look but can be effective because of the 180° diagonal coverage.

surrounding the center area provide the best reason for using such a lens. At the same time, keep in mind that the curved lines are only created off center. Straight lines going exactly through the center (vertically, horizontally or diagonally) remain perfectly straight. This means you can also create images that hardly reveal the use of the fisheye lens. If you place the horizon or a tree trunk in the center of the image, it may almost look like an "ordinary" picture—but only "almost." While the image may not have the typical fisheye look, the 180° diagonal angle of view of the lens covers a much larger area than any wide-angle lens. If you compose a round subject (the face of a clock, for example), perfectly centered, you also maintain the perfectly round shape of the clock. The possibility of producing such non-fisheye images is a second advantage of the full-frame fisheye design.

■ STRAIGHTENING VERTICALS

Tilting

THE CAMERA

RESULTS IN

SLANTED

LINES.

When photographing subjects with parallel vertical lines, like the lines of a building, the vertical lines are recorded parallel only if the image plane is parallel to the subject (in this case, the building). Tilting the camera results in slanted lines. While this may be a perfectly normal view—it also happens when we tilt our head to look at a skyscraper—it can look like a technical fault if the lines are only slightly slanted, making it obvious that the camera was tilted just to get the entire building into the picture. Slanted verticals can be effective—but only to create something different.

It is often possible to "straighten out" verticals by photographing from a longer distance with a longer focal length lens. The longer distance eliminates or reduces the need for tilting the camera. If this is not possible, a lens or teleconverter with perspective control (PC) can help.

Tilting a camera results in the slanted verticals that are unacceptable in most architectural pictures (above). Perspective control allows covering the same area without tilting the camera (right).

Perspective control in a 35mm or medium format camera can produce very professional architectural images without the need for carrying a large format camera. This photo was taken in Germany.

Perspective Control Lenses. On PC lenses or PC teleconverters, a mechanical arrangement allows the optics to be shifted upward and downward to cover more area above or below the subject without tilting the camera. To be able to do this, the PC lens (or lens combined with a PC converter) must have a larger covering power than the image area on the film. The lens can then be moved out of the optical center without objectionable sharpness loss or vignetting. Vertical lines can also be straightened out by shifting the image plane up or down, again while keeping the image and the lens plane parallel to the subject. This is possible on large format and special medium format camera types.

ACHIEVING THE ULTIMATE EXPOSURE

The ultimate quality in a photographic image can only be obtained if the negative or transparency is properly exposed. A seasoned photographer may determine the lens settings for correct exposure based on experience. Most photographers, on the other hand, will rely on the reading from an exposure meter (which can be a separate meter or one built into the camera), or on the automatic exposure control built into many 35mm or medium format cameras.

■ LIGHT METERS

Exposure information can be obtained either by measuring the amount of light that falls on the subject (incident meters) or the light that is reflected from the subject (reflected types).

Incident meters have a dome-like fixture measuring the light that falls on the subject from all different directions. The advantage of this type of meter is that the

reading is unaffected by the brightness or the color of the subject. The reading is therefore the same regardless of the color or brightness of the subject, and the reading is usually correct, whether the subject is white, black, gray or any other color. There is not much more you must learn about the use of an incident meter. Incident meter readings are made by pointing the metering cell from the subject toward the camera lens. The meter reading therefore has to be taken from the position of the subject, not from the camera.

While this is usually no drawback in the studio, or in some location work from a tripod, it is a time-consuming process and practically useless for handheld work done in varied lighting situations.

A reflected meter can be handheld, or can be built into a camera. This type of meter offers the advantage of a meter

reading that can be taken from the camera position. This is helpful outdoors—especially for handheld work. A reflected meter reading is, however, affected not only by the amount of light that falls on the subject, but also by the color and brightness of the subject, giving a higher reading for light subjects and a lower one for darker ones. To obtain perfect exposures with reflected light meters, you must know a little more about the proper use of the meter.

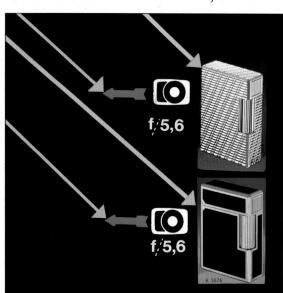

With an incident exposure meter, the reading is determined only by the amount of light that falls on the subject and is the same for bright and dark subjects.

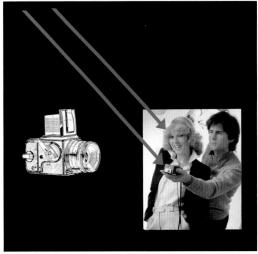

Most incident meter readings must be made from the position of the subject, which is often inconvenient or impossible. An incident meter reading, however, gives the correct exposure even with subjects (like the boat on the left) that have no areas with 18% reflectance.

Reflected meter readings (such as the meter built into a camera) can be made from the camera position, which allows faster shooting and is more practical for handheld work. Taking a reflected meter reading off a subject with 18% reflectance (like the brown and gray street surface in the photo on the left) eliminates the need for making exposure adjustments. The original photo in the illustration is by Carrebye-Fotografi A/S from a Hasselblad Wide Angle brochure.

Using Exposure Meters. Any exposure meter can give the photographer the correct lens settings, but only if it is used properly. Whatever type meter is being used, the photographer must determine what area of the scene or subject to measure, then interpret the reading and decide whether it is correct, or whether an adjustment must be made. This applies even to the use of built-in meters. For more on this, see page 55.

Light Reflectance and Average Subject Brightness. With reflected meters (including built-in meters), the color and brightness of the subject must always be considered when taking a meter reading. The measuring cell in this type of metering device is adjusted at the factory to produce an accurate reading for a middle gray tone (or any color and shade that reflects about 18% of the light that hits it). The meter reading is, therefore, *only* correct when an area of 18% reflectance is measured. When measuring a darker or brighter area—regardless of the film being used, transparency or negative—an adjustment must be made. When measuring brighter areas, increase exposure (open the aperture or lengthen the shutter speed). For a meter reading of white snow, for example, increase exposure by two EV values or two *f*-stops. When measuring darker areas, decrease exposure (close the aperture or shorten the shutter speed). For dark green, dark red or brown, decrease exposure by one EV value or one *f*-stop.

What is Average Brightness? The Kodak gray card is the most accurate reference point for a precise 18% reflectance. Most subjects that we photograph are not in gray tones, but in different shades of colors. Each color reflects a different amount of

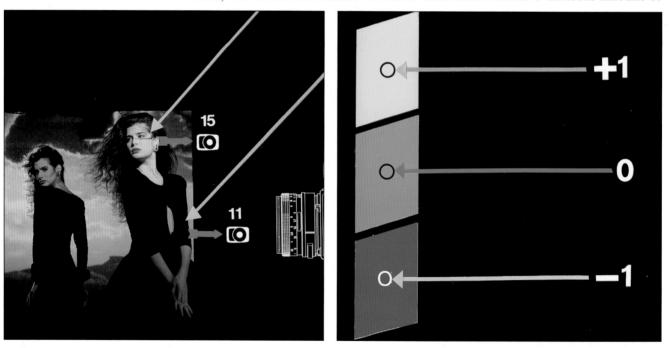

Left—A reflected meter, or a meter built into a camera, will give a higher reading when pointed at a brighter subject area, even if the same amount of light falls on the light and dark areas. The photo used in this illustration was taken by Steven Talley from Forum 4/90.

Right—A reading with a reflected or built-in meter is correct only when it comes from an area that reflects 18% of the light (light green). When the reading is made of brighter areas (yellow, or the misty scene in Canada on the opposite page), exposure must be increased; when made of darker areas (blue), exposure must be decreased.

light. The color chart below illustrates which colors and shades are average brightness (column 0) and which are brighter or darker, with the necessary increase or decrease in EV or f-stops values (from +2 to -1) indicated on top. Use this chart as a guide. You will quickly learn to evaluate subject brightness.

The reflectance values for different shades and colors. The colors in column 0 reflect 18% and therefore give the correct exposure with a reflected or builtin light meter. Meter readings of the colors in columns +1 or +2 need a one or two stop increase respectively in exposure. Reflected meter readings of the darker colors in column -1 need a one stop decrease in exposure. The numbers on the bottom refer to equivalent zone values, zone V for 18% reflectance.

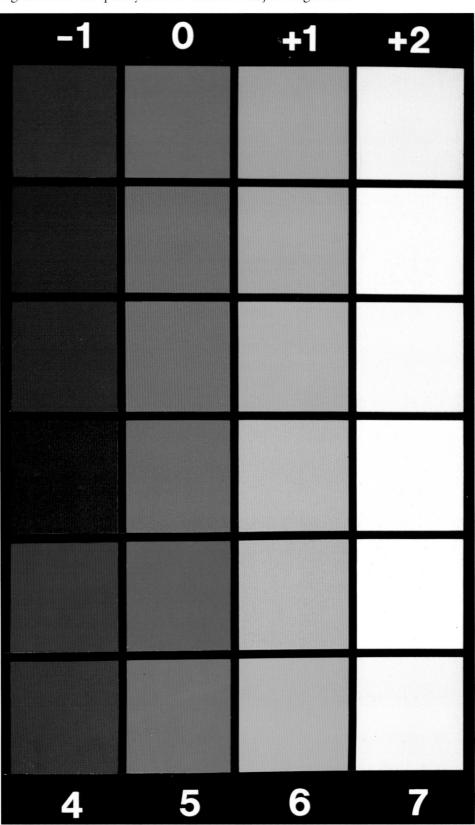

■ THE METERING APPROACH

Exposing for Negative Film. Negatives (black & white or color) must have adequate details in the primary shadow areas, otherwise they will not produce satisfactory prints. Therefore, they must be exposed for shadow density. This makes it essential that you evaluate the scene, especially the shaded areas. Some shaded areas are undoubtedly darker than others. Determine which ones need to show detail on the negative and take the meter reading from such an area.

Exposure for Transparency Film. Transparency (positive) films must generally be exposed for the lighted areas, otherwise highlights look overexposed, become washed out, and lose color saturation. The meter reading therefore must be based on a light area.

This approach to measuring lighted or shaded areas depending on the film in the camera must be used with all meters: reflected, incident, built-in.

When the subject includes lighted and shaded areas (left), exposure is different for negative and transparency films. With transparency films (Pos), you must expose for an 18% reflectance area in the lighted part of the subject. Negative films (Neg) need shadow detail. You must therefore consider the shaded areas when taking a meter reading. Original photo in diagram by Josip Ciganovic from Forum 2/87.

ADVANTAGE OF TTL METERING

A reflected meter reading can be made with a handheld or a built-in meter. A metering system built into a camera or prism viewfinder (called TTL or "through the lens" metering) has many advantages beyond the fact that you need not carry a separate meter, or have partial or complete exposure automation.

First, taking a reading with a separate handheld meter is a time-consuming process—and most impractical in handheld work. Transferring the information from a meter to the camera can easily result in mistakes. With a handheld meter (except a spot meter), you also never know exactly what area you are measuring. With a built-in meter, the measured area is more clearly or exactly defined on the focusing

The reflectance values must be considered carefully with a built-in or separate spot meter. For a correct reading, the spot must be pointed at an 18% reflectance area (here, the green grass) within the subject. The reading must be adjusted when measuring brighter or darker areas. A spot meter, however, always shows exactly the area that is measured and should be considered the ultimate metering instrument.

screen. With the light measured through the lens, the meter reading is automatically adjusted to the area coverage of the lens being used for the picture. When the lens is changed, the measuring angle of the meter also changes. Changes in subject brightness may also be seen while viewing the subject. Additionally, the meter reading is *through* any filters or close-up accessories (such as bellows or tubes) that may be in front of the lens or between the lens and camera. Thus, the meter automatically compensates for filter and extension factors. With a meter built into the camera, you may also see the lens settings right in the viewfinder and receive all kinds of warning signals indicating that something needs to be done before the picture is taken.

A metering system built into a 35mm or medium format camera has definite advantages even for serious professional work. This is the case not because of automation, but because a good built-in spot or center metering system can provide much more accurate metering of specific and known areas, and do so in much less time.

■ Built-in Metering Methods

To obtain good exposure with a built-in meter, you must know how the built-in meter measures the light. This varies from one camera to another, so study the instruction book. The most common approaches are:

- 1. Matrix metering where the meter measures different subject areas. A built-in "computer" then figures out a good average. Matrix metering provides the most consistent results in the fully automatic mode, but because you do not know how much each area affects the reading, you really don't know what you are metering.
- 2. Center weighted means that the metering cell measures the entire subject area seen in the finder, but most of the metering is done in the center. While

- you do not see the exact area that is measured, you have a fairly clear idea of what part of the subject is or should be measured.
- **3.** Center metering is similar to center weighted but only measures the center of the viewing field, not the edges and corners of the image. The instruction manual should indicate the measuring area.
- **4.** In a spot meter, built into the camera or handheld, the exposure is based mainly or only on the spot indicated on the focusing screen. You can point the spot at any area within the subject and see in the viewfinder the exact

With a spot meter, you can determine accurately what area is measured and select one that reflects 18% of the light, such as red and green (top, left). The spot meter reading is not affected by dark or light background areas (top, right). Using a spot meter makes it easy to measure lighted or shaded (areas or both) (bottom, left). You can therefore determine all the different brightness values, which is helpful in black & white photography and necessary when working with the zone system (bottom, right).

area that is measured, including the color and brightness of the area. You know whether you are measuring a lighted or shaded part of the picture. You can also measure different areas of the subject to determine the contrast range. The camera with a built-in spot meter should never be used in the automatic mode because the spot may measure the wrong area.

Remember that all built-in metering systems measure the light reflected off the subject. You must consider not only the area that is measured, but also the brightness of the area.

A built-in matrix or center metering system provides excellent exposures automatically for many outdoor subjects. This image was taken in Nova Scotia, Canada.

■ Use of Automatic Exposure Cameras

In the majority of picture situations, an automatic matrix or center metering system provides excellent exposures on negative, or even transparency film. In a point & shoot camera, the metering system probably sets everything—the aperture and shutter speed—automatically. You may not even know what the settings are.

In other cameras, you can preset either the aperture or shutter speed. The rest is done automatically. For serious work, you want this type and you definitely want a camera where you can see exactly what the aperture and shutter speed settings are.

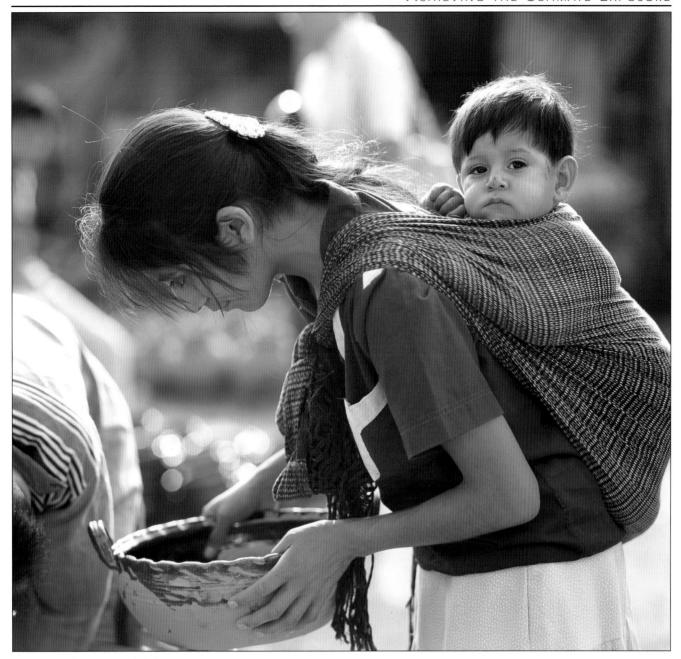

With such a camera, exposure automation should not be considered just an approach for snapshooting. Automatic exposure has a definite place in serious photography—a photographer can be instantly and constantly ready to take pictures, capturing images that might have been missed if a meter reading had to be taken first. I love, and would never want to be without, the exposure automation when photographing people on marketplaces, in the streets, in temples, and when making candid photographs of children. The automatic exposure system has often allowed me to record the people on film long before they even realized that they were being photographed.

The important point with any type of automation is for the photographer to determine where and when the automation has advantages and should therefore be used—and in which cases manual help is needed to accomplish the results the photographer desires.

A built-in automatic exposure system is especially helpful for taking candid photographs of people.

Colors can be changed in developing. For example, developing transparency film, normally done in E6 (left), as compared to C41 developer (right).

■ THE ZONE SYSTEM

Ansel Adams put the basics of exposure into a system with ten brightness values (Zones) from white to black with a middle tone of 18% reflectance being Zone V. In this system, a reflected light meter reading would record any brightness value—white, gray or black—as Zone V. Therefore, with careful metering, the photographer can place every shade of gray in a scene into a Zone, and ensure that important elements are recorded precisely as the tone he desires.

The second part of the system takes advantage of the opportunity in black & white photography to change the contrast of the negative by changing exposure and developing times. An increase in exposure of ½ to one stop and shortening of the developing time by about 20% will produce a lower contrast—a recommended procedure when photographing subjects with a high contrast. The opposite approach, decreasing the exposure about ½ to one stop and lengthening the developing time, is recommended for low contrast subjects such as a landscape in fog. This will increase the contrast on the negative. Ansel Adams formalized this ideas into a system with specific -N and +N values (based on the variation in development from normal—the "N" value). Following his instructions should produce a normal negative of any subject printable on standard grade paper—with low or high contrast. For details, study a good Zone System book.

The zone system cannot be fully used in color photography, however, as the film developing time cannot be changed to produce higher or lower contrast. The basic zone idea, however, can be effectively applied. Just as we can place every shade of gray into a Zone, we can place every shade of color into a Zone. Any color that reflects 18% becomes a Zone V. Colors that are one stop brighter are placed in Zone VI. Very bright colors that require increasing exposure by two stops (like snow) become Zone VII. Darker shades that require a one or two stop decrease become Zone III or IV. These Zone values are indicated at the bottom of the color chart on page 54.

Because you can easily forget whether exposure needs to be increased or decreased, using Zones might make it easier to remember the necessary adjustments in exposure. For example, snow requires a two stop increase in exposure based on a reflected light meter reading. You may find it easier to remember, instead, that snow must be placed in Zone VII (white with detail). This approach is especially helpful with a meter that shows Zone values.

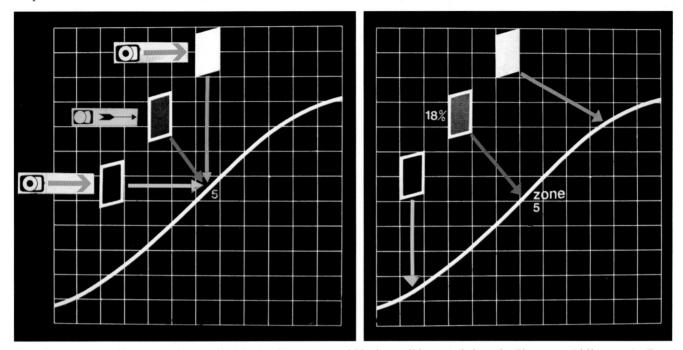

Based on a reflected meter reading, all shades—white, gray and black—will be recorded on the film as a middle gray, in Zone V (left). To record the different shades properly on the gray scale (right), the reflected meter reading for the brighter shades must be increased, about two stops for white. The readings from the darker shades must be decreased. Incident meter readings do not require this adjustment.

LOCATION FLASH PHOTOGRAPHY

LECTRONIC FLASH IS A SIMPLE AND CONVENIENT LIGHT SOURCE FOR BOTH INDOOR and outdoor work, either to add illumination or to make the lighting more effective and beautiful. Flash photography has become automated. This is especially true in the 35mm and the APS formats, where the flash unit is frequently built into the camera and where flash photography is reduced to one operation: push the button. This is fine for snapshots where you just want to get good exposure without creating any special mood or any special lighting ratio between the flash and existing light. Even as a serious photographer, you may want to use this approach for your family snapshots.

Automatic dedicated flash exposure with a compact flash unit right on the camera. A slow shutter speed of 1/30 second produced some blur to enhance the feeling that the dancer is moving. ISO 100 film at f/2. This photo was taken in Thailand.

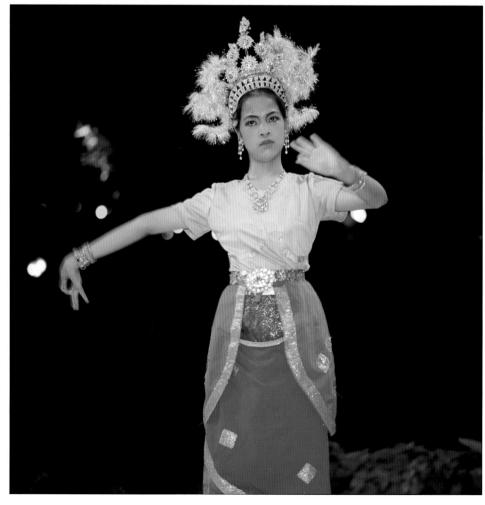

The soft light on an overcast, foggy or rainy day can produce "moody" people pictures that do not call for the use of flash. The bright white sky, however, requires the use of a good lens shade for producing images of the best possible contrast. On a rainy day, as here in Indonesia, the shade also prevents raindrops from falling on the lens surface.

For serious work, on the other hand, you want to control the exposure for the flash and for the existing light. You want to know beforehand what the results will be. To do this, you need a camera that gives you this manual control. Many 35mm cameras do not. Check the camera specifications carefully. You must also learn how these controls work and how to operate them. While a flash built into the camera or placed on top of it is fine for many applications, you may also want the option of separating flash and camera or using a second flash unit for better results. These options exist with better 35mm cameras, and with medium format cameras (where the flash is always a separate unit). For this type of serious work, there are three basic approaches for flash exposure.

■ Manual Flash

In manual operation, the flash always produces the same amount of light, regardless of how far it is from the subject. As the amount of light on the subject is dependent on the distance, the lens aperture must be adjusted to the flash-to-subject distance. The farther the distance, the larger the aperture must be. There is usually a chart on the flash unit that gives you this information for different film sensitivities, so you don't need to make calculations.

If you want to make the calculations, keep in mind that everything with light works in the square root of two (which is 1.4). That means if you want to increase the light of any light source the equivalent of one f-stop, you should move the light 1.4x closer. The f-stops on your lenses are also based on the same factor of 1.4. In fact, you can use these figures instead of making distance calculations. If a light is sixteen feet from the subject, you move it to eleven feet to get one more stop of light (just as from f/16 to f/11 is one stop difference). This also works in meters. Moving the light from 2.8m to 4m reduces the light one f-stop.

Manual flash is great when the flash is at a fixed distance from the subject, as in studio applications, but will slow you down when the flash is part of the camera or mounted on the camera. Whenever you move closer to or farther from the subject, you must change the aperture. So, manual flash should not be considered for such applications.

■ AUTOMATIC FLASH

With the film's ISO set on the flash unit in the automatic mode, a sensor on the flash unit determines the duration of the flash. The duration is shorter when the flash is close to the subject (or the lens is set to a large aperture), and longer when the subject is farther away (or a smaller aperture is used). You can, therefore, move closer to or farther away from the subject without making any changes in the lens aperture. Although you do not know or see what part of the image the sensor measures, automatic flash produces good results in most cases. The automatic mode also allows fast shooting—even from different distances. Additionally, most units have an

adjustment for reducing the flash illumination to ½ or ¼ power (or even further).

■ DEDICATED FLASH

The modern location flash approach is known as "dedicated." The flash is electronically coupled to the camera with the light measured by a sensor in the camera. The flash unit may be part of the camera or separate (as in the medium format). If the separate flash unit is not (or cannot be) electronically coupled to the camera, the flash can still be used in either the automatic or manual mode. A dedicated system is completely automatic in some cameras, without giving you any option for control. In others, you maintain control over all the lens

and camera settings and the resulting exposure. You can select the aperture and shutter speed that produces the desired depth of field and the desired exposure for the existing light. In most cases, you also have the ability to control the flash exposure. For serious and professional location flash photography, you must select a camera that gives you full control of aperture and shutter speed and also allows you to control the flash exposure.

Advantages of Dedicated Flash. Both automatic and dedicated flash give you the freedom to move around, photographing from different distances without worrying about aperture adjustments. This approach allows you to capture action instantly and with consistently good exposures, both indoors (where flash may be

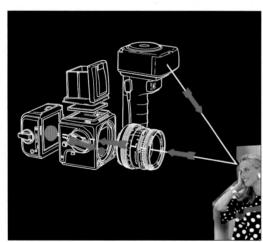

In a dedicated flash system in 35mm or medium format cameras, a sensor in the camera measures the light reflected off the film plane and turns off the flash when it has received the proper amount of light. The light is also measured through the lens and the ready light is visible in the viewfinder.

Dedicated flash provides surprisingly accurate exposures while giving you the freedom of changing the flash-to-subject distance without any changes in the lens setting.

A DEDICATED

SYSTEM ALSO

REDUCES

THE DANGER

OF MAKING

MISTAKES.

the main light) or outdoors (where flash is used to fill in shaded areas). The dedicated mode has many additional advantages that really make it the modern location flash approach. Exposures are amazingly accurate and consistent because they are based on the light that actually falls on the film. The light is also measured through the lens. The measuring area is thus directly related to the area coverage of each lens. The flash-ready light is also visible in the camera's viewfinder, so you can keep your eye constantly in the finder and never lose contact with your subject.

Dedicated flash gives you the peace of knowing that exposures are correct because an exposure signal shows whether the film received sufficient light. This signal is also visible in the camera's viewfinder. A dedicated system also reduces the danger of making mistakes, such as shooting at a shutter speed that is not synchronized for flash. There are usually warning signals or controls in the camera to minimize this possibility. A good dedicated system will also offer simple solutions for changing the flash exposure in fractions of *f*-stops.

Dedicated flash units made specifically for a camera system are electronically dedicated to the camera and need (or have) no adjustments. Other flash units are dedicated by setting them to TTL. That bypasses all settings on the flash, including the ISO, which is set on the camera.

■ Making the Existing Light Part of the Picture

Although any shutter speed that synchronizes for flash produces the proper exposures for the flash lit subject, this exposure may not produce the most effective image. This is because it does not consider the amount of existing light in the room, or the brightness of the daylight outdoors. You want this existing light part of your

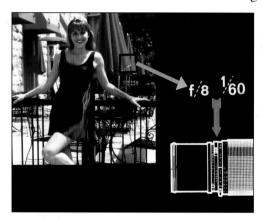

To balance the existing light with flash, take a meter reading of the existing light (the daylight) and the background in a portrait. Then make the lens settings accordingly (above). The flash exposure is automatic (right).

picture. All location flash photography—indoors or out—is done in existing light (daylight outdoors, daylight or interior lighting indoors). Outdoor pictures, and many flash pictures indoors, are more effective and look more natural when the existing light is part of the image. This allows you to see the location, rather than people simply surrounded by darkness. In these circumstances, the electronic flash should be used to augment (not replace) the existing lighting.

It is simple to produce such flash images, but the shutter speed must be set carefully, since it determines to what extent the existing light becomes part of the picture. Start by measuring the daylight, or the room light, using your usual metering method with a built-in or handheld meter. Then decide whether the background should be recorded as it is, brighter, or darker, and use the meter reading to produce the desired results.

Indoor portraits, with the exposure based on existing light, can be improved tremendously by adding flash subtly. The indoor light is still the main light, which is the way many indoor flash pictures should look.

While flash can improve any outdoor portrait, the results are usually most effective in sunlight, used either as a sidelight or a backlight. The photo above is an example of sunlight used as a backlight.

If you set the aperture and shutter speed as shown on the meter, the background will be recorded at the "normal" level. You can make it darker by selecting a shorter shutter speed, or lighter by setting to a longer shutter speed (without changing the aperture). When using a focal plane shutter, the shutter speed must not be shorter than specified in the instruction book. In this scenario, a lens shutter synchronizing for flash at all shutter speeds has a definite advantage—especially in medium format cameras where focal plane flash sync may be limited to speeds up to ½0 second or even ½0 second.

In bright sunlight, it is often desirable or necessary to shoot at ½50 or even ½500 second. The high shutter speed allows you to use a larger aperture, which in turn requires less power from the flash. This means you can do your location flash work with a more compact, lighter unit, and that you get many more flashes from one battery charge.

The high

SHUTTER SPEED

ALLOWS YOU

TO USE

A LARGER

APERTURE...

■ FLASH EXPOSURE

The flash exposure determined by the sensor in the camera produces the desired results in many situations, especially for indoor photography where the flash is usually the main light.

In other situations, particularly outdoors where the flash is meant to fill in the shaded areas with the sunlight remaining the main light source, a reduction in the flash exposure will likely produce a more natural image—with the sunlight being brighter than the flash fill. In such cases, the use of flash should be hardly noticeable. For this purpose, you need a camera that offers this adjustment to at least -2 *f*-stops (preferably to -3 stops). The adjustment is usually made electronically by programming a flash fill value in fractions of *f*-stops into the camera. To determine the best value for your type of photography, it is best to make a film test with your camera and film and have the film processed in your laboratory. In place of a film test, I suggest the following. For outdoor portraits, in the diffused light of an overcast day, or on a sunny day (with the sunlight used as a back or side light), reduce the flash to -1½ to -3. When flash is the main light, you usually do not reduce the flash unless the picture is made in a very bright room.

On some medium format cameras without a built-in meter, the reduction in the flash exposure is made by increasing the flash ISO setting (on the camera). If you set the ISO to 200 for 100 ISO film, the flash exposure is reduced one *f*-stop. With automatic flash, the adjustment is made the same way, increasing the ISO setting on the automatic flash unit.

■ Subject Brightness

While dedicated and automatic flash produce good exposures in most situations, be aware that they can produce perfect results only if the subject that reflects the light to the sensor has an 18% reflectance value—a medium shade of color. A bright subject reflects more light to the sensor and shortens the flash duration, causing underexposure. You can compensate for this by setting the flash fill function to a plus value, or setting the ISO dial to a lower setting (ISO 50 for ISO 100 film lengthens the flash duration). In practical photography, the differences seldom

Outdoor portraits look more natural when the flash exposure is reduced, which is possible on better 35mm and medium format cameras. In the top photo, the flash was reduced the equivalent of ½ f-stop—which still looks too bright. With a reduction of two f-stops, as shown in the bottom photo, one is hardly aware of the flash. The picture is more natural looking.

exceed more than ½ f-stop, not really enough to be concerned with negative film. This is true even in a wedding photograph with a bride dressed in white. Here, most images probably include not only white but other shades, flowers, flesh tones or the groom's black tuxedo, as well.

FILM REFLECTANCE

In a dedicated flash system, the sensor measures the light reflected off the film emulsion. Therefore, the sensor must be matched to the reflectance of the film. There are reflectance differences among the films, which are usually not pointed out to the photographer. The differences are not too great (especially among transparency films) and rarely exceed ½ of an *f*-stop with negative emulsions reflecting more light, causing slight underexposure. The range grows with special films, such as Polaroid. I suggest that you make your own film tests with your dedicated flash system. Photograph a subject, preferably with 18% reflectance on your type of film, and have the film processed in your lab. Underexposure can be corrected by setting the flash fill fraction to a + value, or the ISO to a lower value. When making the film test, make certain that the entire subject area measured by the sensor has the same reflectance, preferably 18%.

■ Producing Better Flash Illumination

The flash head on some portable flash units is small, producing a very directional, harsh light with sharply outlined shadow lines. Placing a diffusion filter over the flash head only reduces the amount of light, but does not produce a softer light. To produce a softer light in the studio or on location, you must increase the size of the light source so the light hits the subject from somewhat different angles.

Soft boxes accomplish such soft lighting beautifully in the studio and, of course, on location. For professional work—such as fashion photography on location—you may want to use a professional soft box. For most location work, where you must be mobile, you can add a small softbox over the flash head of a portable unit. Such units are available from various companies in sizes ranging from about 5"to 7" and are usable with most flash heads. Adding the box reduces the light somewhat, but this is more than compensated for by the beautiful results. The portraits no longer look like flash snapshots but have softer, perhaps almost invisible shadow lines.

Some photographers accomplish similar results with reflected flash. In this technique, the flash head is pointed upward toward a white reflecting bouncer attached to the flash. The reflector, which must be larger than the flash head, then bounces the light into the subject. I have found the use of a small softbox more practical.

■ Color of Light and Flash

When combining flash with existing light, you must also pay attention to the color of both light sources. You want to match the two light sources as closely as possible. There is no problem during regular daylight hours, as electronic flash has about the same color temperature as noontime sunlight. If you use flash as a fill light early in the morning or late afternoon, the flash fill will be too blue and cold compared to the warm sunlight. Placing a warming filter (such as 81B or 81C) over the flash

The flash head

ON SOME PORTABLE

FLASH UNITS

IS SMALL,

PRODUCING

A VERY

DIRECTIONAL.

HARSH LIGHT.

unit should help. Gelatin filters are good for this purpose. Since the filter is used only to change the color of the light (you don't take the picture through it), the quality of the filter is not important.

MULTIPLE FLASH

If flash is used as fill light, a flash unit on the camera produces excellent results. Used as a main light, you can produce more professional results by using two flash heads—a main light and a fill as you would in a studio setup. Also, like in a studio, the main light is a side or ¾ light, and the fill light can come right from the camera. Both flash units must fire simultaneously. This can be accomplished with wires, or in a more professional and practical way with slave units. The flash on the camera then fires the remote main light by means of infrared or radio signals.

The main light on the side can be used in the manual mode—setting it at the distance based on the lens aperture, or in the automatic fashion—so you need not worry about the distance. The fill light on or near the camera should be in the automatic or dedicated mode. It is fired from the flash sync contact on the camera or lens. The fill light should be reduced at least the equivalent of one *f*-stop, probably even more. You do this with the flash fill function or the ISO setting, depending on the system or mode you are using.

■ FLASH APPLICATIONS

Flash can improve location photography—and not only when photographing people. The addition of flash can improve any pictures taken on location with poor or unknown lighting. For example, fluorescent lights do not produce good colors. Flash, which is matched to daylight color film, can help to produce more pleasing colors (especially flesh tones). The flash is then an addition to the fluorescent light, not a replacement—and not necessarily used to light the entire room, only the people in the room. Take a normal meter reading of the existing light as usual and set aperture and shutter speed accordingly. To reduce the effect of the fluorescent illumination, change to a shorter shutter speed—perhaps to 1/60 second or even 1/125, if the meter indicates 1/30 second.

Flash also has a wonderful application in nature photography. When the sky is overcast, producing flat lighting, flash can add contrast and produce lighted and shaded areas, making your nature shots look as if they were taken in sunlight. Wooded areas may be in complete shade even on a sunny day, resulting in long exposures—frequently associated with a blue color cast. Flash eliminates all problems and simplifies the photography by allowing a shorter shutter speed. The short flash duration also reduces the danger of camera or subject movement. Even when the lighting is fairly decent, flash has the advantage of giving you complete control over the lighting. You can place the flash unit so it produces a front, side, back or overhead light without having to wait for the sun to move to the proper spot.

■ Indoor Flash Photography

When using portable flash indoors, I recommend that you consider the existing light in the room whenever possible, instead of taking such pictures at any aperture

Flash can improve

LOCATION PHOTOGRAPHY—

AND NOT ONLY WHEN

PHOTOGRAPHING

PEOPLE.

or shutter speed combination that might seem practical. This approach will, in many cases, reward you with more effective flash pictures where the room is part of the photo instead of the people being surrounded in darkness. This approach can be especially useful in social functions, such as weddings, which are frequently held in beautifully decorated rooms.

Basically, we are using the same approach as we do in an outdoor portrait where we set the aperture and shutter speed to record the surrounding area and background with the proper exposure. When shooting indoors, take a meter reading of the existing light (daylight, tungsten) in the room, then try to use an aperture/shutter speed combination that provides the proper exposure for the existing light or something close to it.

Obviously, since the amount of existing light in the room is limited, your possibilities are also limited if you need to work at shutter speeds short enough for handheld work or moving subjects. Even an aperture/shutter speed combination that is one or two stops less than necessary for the room makes the background visible and is better than taking all the pictures automatically at ½25 second. A one stop underexposure may even be preferable. Inside a church, for example, you may want to put the camera on a tripod for some overall shots.

Using a faster film, such as 400 ISO, instead of 100, also gives you much more leeway and at the same time may allow you to work with a more compact flash unit. Do not hesitate to use fairly slow shutter speeds, such as ½0 or 1/60 second, with flash. The flash duration is short, eliminating the danger of unsharpness due to camera motion—at least in the flash-lit subjects.

While the shutter speed doesn't affect the flash exposure, it does determine the exposure for the existing light. A slower shutter speed, ½5 second for example, makes the room part of the picture (left). A shorter shutter speed of ½0 second keeps the room dark (right). The dedicated flash exposure is the same.

CLOSE-UP PHOTOGRAPHY

Lavailable for many 35mm cameras. They are operated like "ordinary" lenses but focus much closer, usually down to mere inches. They simplify close-up photography, since most or all work can be done without adding accessories. These lenses are usually optically designed to provide good image quality at close distances. Non-macro lenses on 35mm or medium format cameras allow taking pictures below their minimum distance with the use of accessories. That does not necessarily complicate close-up photography, but you must know the accessories, what they do and how they must be used.

■ MAGNIFICATION

EVERYTHING

IN CLOSE-UP

PHOTOGRAPHY

REVOLVES

AROUND

MAGNIFICATION

Everything in close-up photography revolves around magnification: the relationship between the size of the actual subject and the size of the image as recorded in the camera or seen on the focusing screen. As the size of the subject is usually known in close-up photography, magnification can be determined quickly—even before you set up the camera—by relating the subject size to the negative size. For 35mm photography, the negative size is 24mm x 36mm, for a 6cm x 6cm square medium format camera the negative size is 55mm x 55mm. If the subject is about the same size as the negative, we have 1:1 or life-size magnification. If the subject is twice as large, we must bring it down to half its size, which means $\frac{1}{2}$ x, or 1:2 magnification. If the subject is only about half the size of the film format, we enlarge it and have 2x or 2:1 magnification.

■ CLOSE-UP LENSES

For low magnification work, when you wish to go just below the minimum focusing distance of the lens (for example, to focus down to two feet when the lens only permits focusing to three feet), close-up lenses are the easiest to use. They are mounted on the front of the lens like a filter, and can therefore be attached, changed or removed quickly and easily. They do not require an increase in exposure and they can be used on any type and focal length of lens (including zoom lenses). The power of close-up lenses is frequently indicated in diopters like eyeglasses: +1; +2; +3 diopters. Diopter is another way of expressing the focal length of a lens or system. One diopter equals a one-meter focal length ($39\frac{1}{2}$ "), two diopters equal $\frac{1}{2}$ meter or $19\frac{3}{4}$ ". A half-diopter lens has a focal length of two meters (79").

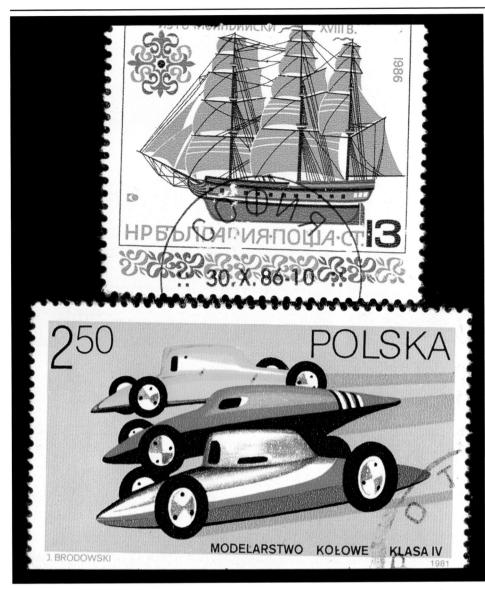

Bottom, Left—Magnification is the ratio in size between the actual subject and its size on the focusing screen or film. If the image is half the size of the subject, we have a 0.5x (or 1:2) magnification. A 2x (or 2:1) magnification exists when the image is twice the size of the subject. If the subject is recorded on the film at its actual size, like the postage stamps (left) on the 6cm x 6cm medium format, we have life-size (or 1:1) magnification.

Bottom, Right—If the area covered (below) is 110mm (or 4½"), and the image format is 54mm (or 2½"), the magnification is 0.5x, or 1:2.

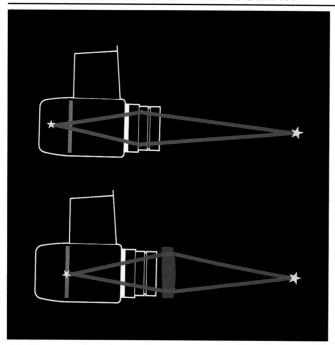

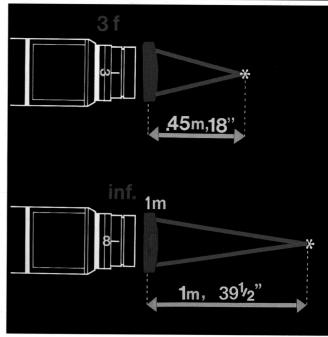

Left—A subject closer than the minimum focusing distance of the lens forms its image behind the image plane (top camera). A Proxar or close-up lens in front of the camera lens can bring the image onto the film plane (bottom camera).

Right—When any lens on any camera is focused to infinity, the distance from the close-up lens to the subject is equal to the focal length of the close-up lens, or one meter (39½") for a one-diopter lens (bottom camera). You can take pictures closer by turning the focusing ring on the lens to a closer distance than infinity (top camera).

This is worth knowing because there is a direct optical relationship between the focal length of a close-up lens and focusing distance. If any lens on any camera is set at infinity, a close-up lens produces a sharp image in the camera when the distance from the close-up lens to the subject is equal to the focal length of the close-up lens—one meter or $39^{1}/2^{11}$ for a one-diopter lens. You can obtain a sharp image at closer distances by turning the focusing ring to closer distances.

To go just below the minimum focusing distance with any lens, select a close-up lens with a focal length roughly equal to the minimum focusing distance. To be more specific:

- For lenses with a minimum focusing distance of 5' or longer, select a two-meter focal length (½ diopter).
- For lenses with a minimum focusing distance of around 3', select the one-meter focal length (one diopter).
- For lenses with a minimum focusing distance of 2' or less, select the ½-meter (two diopters).

The closer you want to go, the stronger the close-up lens needs to be (higher diopter value). You can also combine two lenses. The power of the combination is obtained by adding the two diopter strengths: a + 1 and a + 2 diopter lens yields a + 3, for example.

Close-up lenses do, however, decrease the image quality, especially at the edges. The stronger the lens, the more noticeable the loss of sharpness. With lenses up to two diopters, the loss is usually not objectionable when the lens aperture is closed two to three *f*-stops. Image quality suffers with stronger lenses (three or more diopters) and therefore, I do not recommend them for critical work.

■ EXTENSION TUBES AND BELLOWS

For higher magnification work, and for all close-up photography where image sharpness is important, consider extension tubes or bellows. Both mount between camera and lens and both perform the same function: they allow you to move the lens further away from the image plane. In a way, these accessories extend the focusing range of a lens.

A bellows extended to the same length as a tube produces the same image with the same lens. Which one should you choose? Here are a few points to consider:

- 1. Extension tubes are more compact and easier to carry.
- **2.** Tubes should be considered when the required extension is low. Bellows should be considered for longer extensions.
- **3.** Extension tubes are solid pieces and are able to support any lens, including long, heavy telephotos.
- **4.** Good bellows have two adjusting knobs, one for changing subject distance, the other for changing image distance. This simplifies and speeds up close-up photography. Bellows should be considered for extensive close-up work.
- **5.** A transparency copy holder can be attached to the front of some bellows for simple slide copying.

Length of Tube or Bellows Extension. The area coverage is always determined by the focal length of the lens in relation to the length of the tube or bellows. To cover a smaller area, you can either change to a longer tube (or increase the extension of the bellows) with the same lens, or change to a shorter focal length lens and use the same tube or bellows extension. In either case you will also need to move the camera closer to the subject.

Exposure. Since extension tubes and bellows move the lens farther away from the image plane, exposure must be increased. If the meter reading is taken with a meter in the camera that measures the light through the lens (TTL) there is no need to consider the increase, since the light is also metered through the accessories. If the meter reading is taken with a separate meter, the exposure must be increased.

The correct *f*-value is the *f*-value on the meter multiplied by the focal length of the lens, divided by the quantity of the focal length of the lens plus the extension. (The focal length and the extension length must be in the same units, millimeters, for example.)

Aperture value =
$$\frac{\text{aperture on meter x focal length}}{\text{focal length + extension}}$$

Example for f/11, 50mm focal length and 50mm extension:

Aperture value =
$$\frac{11 \times 50}{50 + 50} = \frac{550}{100} = 5.5$$

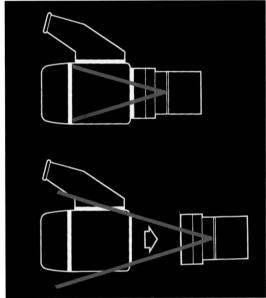

Whenever a lens is moved away from the film plane, exposure must be increased as the light is spread over a larger area.

■ DEPTH OF FIELD WITH DIFFERENT LENSES AND CLOSE-UP ACCESSORIES

Contrary to general belief, depth of field is not affected or determined by the close-up accessory. In practical close-up photography, where you normally want to photograph an area of a specific size, depth of field is again unaffected by the focal length of the lens. Depth of field is determined solely by the area of coverage (magnification) and the lens aperture. For example, at life-size magnification the depth of field at f/11 is about 2mm with any lens or accessory. The only way to increase the depth of field is to stop the lens down further, if this is possible, or cover a larger area and crop out the desired area later. Closing the aperture down two stops will approximately double the depth of field.

Depth of Field at Various Magnifications

Total Depth of Field in mm at f/11

Magnification	A	В			
0. 1x	100	50			
0. 2x	30	15			
0. 3x	15	7			
0. 5x	6	3			
0. 8x	3	1 1/2			
1 x	2	1			

A—for general work

■ PHOTOGRAPHING SUBJECTS LIFE-SIZE

To obtain life-size magnification with any lens, you can add an extension tube or use a bellows extension equal to the focal length of the lens. The distance from the subject to the image plane is then equal to four times the focal length of the lens, and is equally divided between the front and the rear. Life-size magnification with a 6cm x 4.5cm camera means covering an area 55m x 40mm. In 35mm, 1:1 means covering a smaller 24mm x 36mm area. Covering the same 24mm x 36mm area with a 6cm x 4.5cm camera means a higher magnification (about 1.7x) with consequently less depth of field. This is the basic explanation of why depth of field in the medium format is shallower than in 35mm.

THE USE OF

A TRIPOD

IS HIGHLY

RECOMMENDED

■ Photographing Close-Ups

FOR VARIOUS

REASONS.

The use of a tripod is highly recommended for various reasons. Depth of field is shallow, so focusing must be accurate. A slight change in camera position can change the composition or background drastically. In close-up work, backgrounds must be carefully evaluated. Since small apertures are usually called for, shutter speeds may be relatively long. Since close-up photography frequently means low angle photography, a tripod designed for this purpose may have to be considered. A type with a reversible center post may be the solution.

B—for work where critical sharpness is important

Still, don't forget about handheld close-up photography. It can be done with macro lenses or any close-up accessories and can be practical—especially for low angle work. Lying on the ground and resting on your elbows makes a beautiful camera support. In handheld work, automatic focusing is a definite benefit. In the manual approach, do not attempt to focus by turning the focusing ring. You will be more successful if you preset the focusing ring on the lens or the extension on a bellows, then move the camera until the desired part of the subject appears sharp on the focusing screen.

■ LIGHTING

Existing lighting is frequently not effective for close-up work. The subject may be in complete or partial shade, the sun may not be in the right position, or it may be an overcast day resulting in a flat image without shaded and lighted areas. Try to improve the light. Many nature photographers use mirrors. Properly placed, they can reflect sunlight into shaded areas. Indeed, mirrors can improve the lighting, but you are still limited in the choice of aperture and shutter speed, and mirrors must be moved as the sun changes position.

Electronic flash is a better choice. The light from the electronic flash unit can be made to fill shaded areas, or it can become the main light when photographing on an overcast day or in complete shade. If so, take the flash off the camera. Place the light where it produces the most effective image—as a side light, in a ³/₄ position, or as a backlight. You can also use more than one flash unit, or combine the flash with a reflector as you might do in a studio.

A dedicated flash system, measuring the light through the lens and close-up accessory, will in many cases provide the correct exposure automatically. However, since we are combining flash with daylight and the combination of the two lights determines the effectiveness of the final image, a test exposure (on Polaroid, if possible) is recommended. In any case, you must consider the daylight, so start by taking a meter reading of an important area—the background perhaps—and set the aperture and shutter speed accordingly. If you want to make the background lighter or darker to produce the most effective close-up, shorten or lengthen the shutter speed.

■ HIGH MAGNIFICATION PHOTOGRAPHY

With the close-up accessories discussed so far, you can obtain magnifications up to about 2x, which means covering an area about 12mm x 18mm in the 35mm format, or 27mm x 27mm in the square medium format. You may be able to obtain higher magnifications in one of two ways without getting involved in photomicroscopy.

Some 35mm lenses are designed to be used in the reversed fashion, which means mounting them on the camera with the front toward the image plane and camera. Investigate the options and obtain the instructions from the manufacturer.

A few companies make special lenses for high magnification work. They look like objectives for a microscope and come from the microscope division of the optical company. These objectives are used in front of a bellows with a special adapter. The bellows extension is used for focusing. The length of the bellows extension also

Existing

LIGHTING

IS FREQUENTLY

NOT EFFECTIVE

FOR CLOSE-UP

WORK.

determines the magnification, so a wide range of magnifications can be obtained with the same lens. Such lenses are most likely available from camera companies that also manufacture optical instruments, especially microscopes. Contact the manufacturer for details.

High magnification work, covering areas ½" or ¼" in size (5mm–12mm) is fascinating, because such images reveal details that we normally don't see. I have used such lenses to photograph details in postage stamps and the color patterns in fall leaves. They have also been used to produce the 10x blowups from negatives and transparencies published in this book.

High magnification images, such as a small portion of a postage stamp (left and above), can be obtained with a special high magnification lens in combination with a bellows and an adapter to hold the lens. These lenses are usually equipped with a microscope thread. Such a lens was used in this example on a 6cm x 6cm medium format camera.

Many subjects provide wonderful possibilities for fascinating close-up pictures of details that most people overlook, such as the beautiful color pattern on this boat in Portugal.

FILTERS FOR BETTER IMAGE QUALITY AND EFFECT

THERE ARE BASICALLY TWO REASONS FOR USING FILTERS: TO PRODUCE A BETTER OR more effective image, and to add a special effect to an image. Special effect filters allow you to change colors, surround the highlights with streaks or stars, add a blur or fog, produce multiple images, etc. They serve a good purpose in amateur and professional photography. My main reason for using filters, however, is to produce technically better images.

■ FILTERS IN BLACK & WHITE PHOTOGRAPHY

Color filters are helpful in black & white photography because they can be used to darken or lighten subject areas of certain colors. Thus, they enhance the contrast and emphasize or suppress other areas that are of a different color.

In black & white photography, a color filter lightens the subjects that have the same color as the filter, and darkens those that have a color on the opposite side of the color wheel. A yellow filter lightens yellow and darkens blue, for example.

A filter of a given color always transmits the light of that particular color. Red, for example, transmits red. This means that more red light hits the film, making subjects of that color appear lighter in the print. Filters darken subjects that have the color from the opposite side of the color wheel (yellow filters darken blue tones, for example). You can use the color wheel to determine how different color filters change gray tones.

■ NEUTRAL DENSITY FILTERS

Neutral density filters, also called gray filters, are used in both black & white and color photography. Made from neutral gray-colored glass, the neutral density filter is designed to reduce the amount of light reaching the film without changing the tonal rendition of the colors in the subject. This is most helpful outdoors when the light is too bright to permit photography at large apertures, to produce a shallow depth of field, or allow slow shutter speeds for blurred motion or zoom effects. Neutral density filters come in different densities; the most common ones are listed in the chart below.

	Percentage	Increase in Exposure, Exposure Values, or			
	Light				
Density	Transmission	<i>f</i> -stops			
0. 3	50	1			
0. 6	25	2			
0. 9	12	3			

■ LIGHT BALANCE AND CONVERSION FILTERS

Light balance and conversion filters are used in color photography for matching the color quality of the illumination to that of the film. This is necessary when subjects, flesh tones or products must be recorded in their true color. For example, a blue filter can be used to reduce the yellow color cast from incandescent light. A magenta filter can compensate for the green color cast under fluorescents.

Light balance is seldom necessary for landscape photography, though, even when photographed in the warm early morning or late afternoon sunlight. Landscapes are usually photographed at these times because the warm light adds a special touch and mood to the scene. Don't destroy the effect by trying to change the color to match the noontime sunlight.

Light balance and skylight filters have been recommended for outdoor photography on overcast, foggy or rainy days when the color temperature is unknown and is usually higher than sunlight, producing a bluish cast. They were also recommended when photographing into shaded areas on a sunny day. This is because the light in the shade is actually the reflected blue skylight and renders shaded areas with a blue cast. I have found, however, that this correction is no longer necessary with most of today's color films. The tendency for a bluish cast has been reduced. It is no longer objectionable or even visible—especially with the latest transparency films. Because of this, I have not used any warming filters for my slide photography for at least seven years.

DON'T DESTROY

THE EFFECT

BY TRYING

TO CHANGE

THE COLOR

TO MATCH

THE NOONTIME

SUNLIGHT.

A polarizing filter can eliminate reflections from anything except bare metal when the subject is photographed from an angle. This image was taken with a polarizing filter in a cemetery in Buenos Aires.

■ HAZE, UV AND SKYLIGHT FILTERS

Haze and UV (ultraviolet) filters do not change colors to a noticeable degree, they merely absorb UV rays. Most modern lenses, however, have lens elements made from glass that also absorbs UV light and often to a higher degree than a UV filter. Consequently, these filters do not improve pictures to any noticeable degree. UV filters also do not improve distant shots.

Still, I do recommend the use of haze and UV filters for lens protection. Lenses are the most expensive components in a camera system. They are also the components that are most easily damaged and probably the most expensive to repair. A simple way to protect the front element is with an optically plain piece of glass, which is easy to clean and relatively cheap to replace. A skylight, UV, or haze filter can serve this purpose. Each of your lenses should be equipped with a protective filter. It is much too time-consuming to be switching filters from one lens to another every time you change lenses. Each filter should be of the highest quality, as it becomes a part of the lens and every photo will be taken through it. For color photography, use the same filter made by the same company on every lens to avoid possible differences in color rendition.

I DO

RECOMMEND

THE USE OF

HAZE AND UV FILTERS

FOR LENS

PROTECTION.

■ POLARIZING FILTERS

Polarizing filters can improve outdoor photos in various ways:

- 1. The filters can darken skies (especially blue skies) and make them more dramatic on any type of film—color or black & white. This is possible only with sidelight (the sun shining from the side).
- 2. Polarizing filters can improve distant shots by eliminating the haze and bluish cast. The use of such a filter can make a dramatic difference in the quality of such pictures. Again, it works only with sidelight.
- **3.** The filters can increase the color saturation of many outdoor subjects by eliminating or reducing reflections on the surface of the subject.
- **4.** The filters can eliminate reflections on shiny surfaces such as store windows, murals, etc. This happens only if the subject is photographed from an angle of 30° – 40° .
- **5.** The filters can eliminate reflections from water surfaces, which may or may not be desirable. Reflections make water surfaces beautiful and give them life. Use your judgment while viewing the scene with and without the filter. Reflections can be eliminated only when photographing the water surface from an angle.
- 6. Polarization is very helpful for copying.

Polarization in Copying. Copying results can be improved dramatically with polarization. Since the subject, the copy page, painting, photographs, etc., must be photographed straight on at 90 $^{\circ}$ to avoid keystoning (the unwanted convergence of parallel lines), a polarizing filter over the camera lens is not enough. Remember, a polarizing filter on the lens eliminates reflections only when the subject is photographed from a 30 $^{\circ}$ -40 $^{\circ}$ angle. Therefore, for best results, the light that reaches the copy must also be polarized by placing a filter over the light source(s).

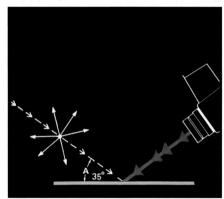

Above—A polarizing filter eliminates reflections only when the subject is photographed from a 30°-40° angle, depending on the material (glass, water, etc.).

Top, Right—Reflections on a water surface can be eliminated with a polarizing filter.

Bottom, Right— However, the filter can also take away the brightness, the life and the beauty that is recorded without the filter. The photographer must make the choice.

Once the filters have been attached to the lights, the filter over the lens is then rotated for what is known as cross polarization. If more than one light is used, the filter over each light source must be rotated in the same direction. This can be checked by placing the filters on top of each other. They are polarized in the same direction when you see the brightest image through the filters.

When using flash (other than a studio type with modeling light), place some kind of a continuous light source (a regular lamp) next to the flash but also behind a polarizing filter. The continuous light is necessary to study the effect on the focusing screen while rotating the filter on the camera lens.

Top, Left and Right—The improvement with polarization is very dramatic (left) compared with the results without it (right).

Left—A copying setup consists of the camera with a polarizing filter over the camera lens, and one or two light sources (flash or tungsten), with polarizing filters over each light source.

A polarizing filter can dramatically improve distant shots (right) by reducing the haze and bluish cast that appear without it (above), but only in sidelight.

■ PARTIAL FILTERING

Filters can also be positioned in front of the lens so that only part of the image receives filtered light. Neutral-density filters can be used to darken select areas or color filters to change colors in certain areas, all while leaving the other areas unfiltered. This is accomplished using special filters that are clear over half of their area, and neutral gray or colored over the other half. They are readily available—especially in the square shape.

When positioning the filter, you must view the ground-glass image at the aperture that will be used. Better yet, determine the aperture that produces the desired results while manually opening and closing the diaphragm. You will find that the position of the dividing line changes as the diaphragm is closed down and that the sharpness of the dividing line between the filtered and nonfiltered area depends on the aperture. With a sharp dividing line between the filtered and nonfiltered areas (such as a horizon over a water surface), small apertures are better since you do not want the sky colors to bleed into the water area. In other cases, a large aperture may be preferred, producing a blurred outline that gradually changes and is less visible.

■ FILTERS FOR INFRARED PHOTOGRAPHY

Filters are used in infrared photography to absorb blue and UV light so that only the deep red and the infrared rays reach the film. For black & white infrared work, a deep red filter is recommended. For experimental and creative color infrared work, any filter can be used—yellow, red, green, blue, purple and violet filters produce beautiful and unusual color effects with many subjects.

EXPOSURE INCREASE

Most filters absorb light, so exposure must be increased to compensate. The amount of loss is mentioned in the instructions or may be engraved on the filter rim. The indication can be in f-values or in filter factors. The two are not the same. Built-in exposure meters measure the light through the filter and compensate automatically, so you need not consider the filter factors.

This may not apply to a polarizing filter, though. Ordinary, or "linear" polarizing filters may not provide the correct meter reading with some built-in metering systems, depending on how the system works. Filter manufacturers, therefore, introduced another type of filter, known as a circular polarizer. This type should give the correct meter reading with any built-in metering system and is usable with any camera—even those that also work with the ordinary linear type.

Filter Factors and f-stops/EV

Filter factor	1.5	2	2.5	4	6	8	16	32	64
Increase in exposure in <i>f</i> -stops or EV value	1/2	1	1 ½	2	2½	3	4	5	6

QUALITY OF FILTERS

Filters used with high-quality lenses for critical photography must be made to the same quality standards as the lens. This is especially important when you use filters all the time, when you add filters to long focal length lenses, or when you combine filters.

Glass filters should be cleaned like lens surfaces, by blowing or brushing off dust, or cleaning them with lens tissue (lens cleaner should be used only if necessary). Never use lens cleaner or any chemical solvent on plastic types. A soft brush or blower will remove dust. Grease or fingerprints can be removed with a soft polishing cloth, after you breathe on the filter surface. Avoid unnecessary brushing and cleaning. Place a lens cap over a filter on the lens, and store loose filters in a case.

■ Special Effect Filters

Special effect filters can change the colors, the sharpness, and the appearance of any scene. They can add stars and color fringes to the subject, or multiply a subject in any fashion. The choice of such filters is extensive. You can use them as you like for fun, but for serious, professional work you may want to be more careful.

The final image should not give the impression that the filter was used as a gimmick. The use of the filter must enhance the image. Some filters create effects that are very unrealistic. The fog filter, for example, produces the effect of fog but does so evenly over the entire image area. This is not the way we see fog, where the foreground subjects are more distinctly visible than those farther away. Because the fog filter does not produce this result, its effect can look very artificial.

SPECIAL EFFECT FILTERS

CAN CHANGE

THE COLORS,

THE SHARPNESS,

AND THE APPEARANCE

OF ANY SCENE.

■ Working with UV Light

Photography in the UV range of the light spectrum can be either UV or fluorescence photography. UV photography is normally limited to special types of

applications—mainly in the forensic and medical fields. It is useful in these fields because things that are invisible in regular light (retouching on paintings, alterations on checks and documents) become visible when photographed in UV radiation. Regular lenses are usable for most UV work. When short-range UV radiation is necessary, special lenses made from quartz rather than glass are necessary, since glass does not transmit those rays. Since all films are sensitive to UV light, any film can be used for work in this field. In most applications, black & white film shows everything you want to see. Color film, on the other hand, must be the choice for fluorescence work.

Fluorescence Photography. Fluorescence photography provides exciting possibilities for creating unusual images on color film. You can use daylight or tungsten film, each producing somewhat different colors. The subject that you photograph must be illuminated with UV light. What you record on the film, however, is the light reflected from the subject—regular, visible light. As a result, no special cameras, lenses or films are needed.

What you need are subjects that fluoresce. If the subject you want to photograph does not, you can paint it with fluorescent paint or lipstick. By illuminating the subject with UV radiation while you apply the fluorescent material, you can see the effect immediately and know what works (or doesn't) and what the effect will look like on film.

To do this, you need a light source that gives out UV radiation. Special fluorescent tubes marked "BLB" are available, but they do not produce a great amount of light and are usable only for subjects that do not move (where you can use a fairly long shutter speed). More practical is electronic flash. All flash units, studio or portable, also produce UV radiation. However, since you need *only* the UV radiation, you will want to eliminate most or all of the visible light. A Kodak 18A filter, placed over the flash unit, serves this purpose. Some manufacturers of studio lights also make special filters for this purpose.

A regular UV filter should also be placed over the camera lens to absorb the UV rays, which have a tendency to add a bluish cast to the image. Exposure is determined (as usual) with an incident meter, a reflected meter in combination with a gray card, or a flash meter if flash is used. I suggest that you make test exposures, since different meters may react somewhat differently to UV light.

FLUORESCENCE

PHOTOGRAPHY

PROVIDES EXCITING

POSSIBILITIES

FOR CREATING

UNUSUAL IMAGES

ON COLOR FILM.

12 PROFESSIONAL SOFT FOCUS PHOTOGRAPHY

REATING A "SOFT TOUCH" OFFERS OPPORTUNITIES FOR PRODUCING BEAUTIFUL images. The soft outlines add a glamorous touch to portraits, bridals, and fashion shots, at the same time reducing the need for negative or print retouching. A softness in images advertising beauty products or things associated with romance, food or drinks can enhance the sales appeal. In landscapes, a soft touch can emphasize the shimmering highlights of a backlit scene.

In most indoor or outdoor portraits, just a touch of softness is necessary (left) to make the image more romantic and reduce the harshness of a "straight" portrait produced with today's high-quality lenses (above).

■ SOFT FOCUS LENS OR SOFT FOCUS FILTER?

A "soft touch" can be produced on black & white or color film with a soft focus lens. However, it is not necessary to invest in a special lens for producing a professional soft touch. An effective professional soft touch can be created with soft filters added to the front of regular sharp lenses. This means you do not have to invest in another lens just for producing soft images (and you won't have to carry an additional lens on location).

Soft focus images outdoors are most effective when the sunlight is used as a sidelight, as in this photo, or backlight.

Filters offer other advantages, as well. With a soft focus lens, all your soft pictures must be made at one focal length—the focal length of that special lens. With soft filters, you can select the focal length that is perfect for that particular shot, and you

can switch from one to the other instantly. You can select a wide angle for an out-door shot, the standard lens for a product shot, group picture or a full-length portrait, and switch to the telephoto for the head and shoulders portrait.

With some soft focus lenses, the degree of softness changes with the aperture. But with most soft focus filters, the degree of softness is not affected by the aperture. I prefer this approach, since I feel that a lens aperture should be used to control depth of field, not the degree of softness. With filters, I can select the lens opening that produces the desired depth of field and I can change the aperture without changing

A good soft focus image must appear sharp with just a slight bleeding of the highlights into the shaded areas. This photograph was taken with a Carl Zeiss Softar filter #1.

the softness. Outdoor scenes, product shots and close-ups may require the smallest aperture for depth of field. A portrait may call for a large aperture to blur the background. With filters, you vary the degree of softness by changing the filter, not the lens aperture—and you can do so on all lenses.

When you evaluate the results produced by a soft focus lens or filter, examine the details in the picture under a good magnifying glass to determine whether the filter or lens produces an overall blur or maintains sharpness. This must be considered carefully because an effective soft focus image needs sharp contours with just a soft glow along the bright edges. It cannot have an overall appearance of unsharpness, because this is not the way we see things; our eyes are used to seeing sharp contours. There is a difference between a professional soft focus and an unsharp image. If the filter maintains sharpness in the image, you have the additional benefit of focusing either with or without the filter on the lens.

■ Creating Effective Soft Focus Images

The desired degree of softness in an image may be determined by the subject and the lighting, or the use of the image. In most cases, however, the degree of softness

For most location portraits, just a touch of softness is most effective. Here, it is produced with a Carl Zeiss Softar filter #1.

is based on the personal preference of the photographer or the client. It is often difficult to make the decision when evaluating the subject on the focusing screen—especially on the smaller screen of 35mm cameras. I suggest that you take the picture not only through one filter, but two or even three, unless you have used the filters before under similar conditions and know what the final results will look like.

For portraits, I prefer just a touch of softness and usually use the filter with the minimum effect. I have used stronger filters for some backlit land-scapes. Soft focus filters or lenses bleed the highlights into the shaded areas of the subject or background. This effect can be disturbing, especially when the "bleeding" goes into a background area, surrounding the subject with a halo. This happens mainly with dark back-

grounds. Evaluate the image carefully on the focusing screen. Try to eliminate or reduce the "bleeding" by keeping the light away from bright subject areas, draping the model with darker clothing, or photographing the subject against a brighter background.

13 ENHANCE THE IMAGE WITH EFFECTIVE COMPOSITION

A GOOD PICTURE MUST HAVE AN ATTENTION-CREATING QUALITY. THIS CAN BE achieved by the subject itself, the lighting, the arrangement of lines, shapes and colors—all usually referred to as composition. While a photograph should convey the personal view of the photographer, following guidelines for arranging the elements can help to create an image that is visually pleasing, powerful and effective in the eyes of the average viewer.

■ Composing in the Square

Some photographers seem to feel that the arrangement of the elements in the square format is different from the rectangular shape. I do not feel that way. The same

Horizontal lines, especially in the square or horizontal format, convey the feeling of peacefulness. This photograph was taken in Portugal.

The gray morning fog across the hillside in Bergen, Norway, formed an excellent balance to the blue-gray water at the bottom of the picture.

guidelines apply. You don't have to learn anything new when switching, for example, from the rectangular 35mm format to the 6cm x 6cm square.

■ SUBJECT PLACEMENT

A single subject in front of a background without any important picture elements usually belongs in the center in any format. That can apply to a frontal portrait, a product in an advertising image, or a close-up of a flower. A centrally placed single element creates an effective composition, but a somewhat static one. Usually, a more moving image is created by placing the main subject approximately ½ from the left or right, or ½ from the top or bottom.

BALANCE

A subject placed to the side does not work with a plain background. Such an image lacks balance: a repetition of lines and shapes—or in color photography, a repetition of the color within the picture format. The "balance elements" must create less attention than the main subject, otherwise they become distracting. You usually do not want two equally attention-creating elements in a picture. Such an arrangement makes the eyes jump from one element to the other.

LINES

Horizontal lines create a feeling of peace and quiet in any format. Use or emphasize horizontals if that is the mood you want to create. For a more dynamic mood, emphasize verticals and diagonals. You can create diagonals artificially by taking some pictures with a tilted camera. Pay special attention to the placement of strong horizontal or vertical lines. Placing them in the center of the image can be effective when there is a repetition of lines, shapes and colors on both sides (such as the subject on one side, its reflection on the other). Such a composition emphasizes the repetition but also splits the image into two equal halves which, in most cases, is not very effective. In most images in any format, strong verticals or horizontals (such as

Left—The main subject (the church on a Greek island) was composed based on the "\sqrt{rule"} that applies to any image format.

Right—The most effective images are frequently nothing more than an interesting arrangement of lines, shapes, and colors. This photo was taken in Malaysia.

Top—Vertical and especially diagonal lines make images in any format more dynamic. Here, the diagonal line separates the foreground and background. This photo was taken in New Zealand.

Right—Dominant lines in the center split the image into two equal halves. A better placement, about ½ to the top or bottom for example, can create a more dynamic picture.

the horizon) are more effectively placed in the ½ position—about ½ from left or right, ½ from top or bottom. By doing this, you force the viewer to look at whatever you feel is more important: the sky if the horizon is ½ from the bottom, the landscape in the foreground if the sky covers only the top ½ of the image.

■ ATTENTION-CREATING ELEMENTS

In a photographic image, any element that is a different shape, size, or color or "moves" in a different direction, creates attention. A red traffic light will attract attention if it is the only red in the picture. A small tree bent diagonally in the midst of large vertical trees will catch our eye because it "moves" in a different direction. So will the one boat that goes vertically among hundreds of boats going horizontally in a harbor scene.

Use such "one-and-only" elements to attract a viewer's eye if they add to the picture, but avoid them if they might distract from what you are trying to show. I find that many otherwise successful images are spoiled by distracting elements. Lines that are expected to be perfectly horizontal or vertical (a horizon, or the sides of a building) will distract if tilted even slightly. Bright areas always attract attention, even if they are nothing more than highlights on a shiny surface. Such bright areas are especially distracting if they appear near the sides or corners of an image, leading the eye out of the picture. Any subject partially cut off by the frame of the image and any dominant line cutting into the frame line of the image will catch a viewer's eye.

The boats in the lower right form an important balance by repeating the colors in the building on the upper left. This photo was taken in the Canadian province of Quebec.

As an example, our eye will instantly go to the church steeple that is cut off by the top of the frame. In principle, any attention-creating element is a plus in a picture if it leads the eye to the main subject; it is a negative if it makes the eye move away.

Top—A good placement for a main subject or a dominant line in any format is about ½ from the top or bottom and ½ from the left or right.

Right—Composing subjects diagonally, such as these wood carvings in Thailand, makes for a more dynamic image. Keeping images simple adds to their visual effectiveness.

Left—It was not the seagull that made me take this picture but the yellow colors on the post framed against the red colors in the background. This photo was taken in New Zealand.

Right—The visual effectiveness of this early morning image in Bavaria is created by including just two colors—blue and green.

■ KEEP THE IMAGE SIMPLE

Good images attract the eye and keep it in one place. They don't make the eye move all over the image, not knowing what is important or what the image is to convey—possibly even making the eye leave the image completely. Such an impression is frequently created by having too many elements within the picture frame. Simplifying by concentrating on one, or at least fewer, elements is frequently the best approach for creating more effective visuals. After you take the first picture, always move in closer and look for other possibilities. In many cases, you will discover that the closer you get, the more you eliminate, and the more effective your visuals will be.

Picture possibilities exist everywhere—even close to home. This photo was taken in New Jersey.

14 BEYOND THE PICTURE POSTCARD

N YOUR TRAVELS, YOU WILL UNDOUBTEDLY BE TEMPTED TO PHOTOGRAPH THE typical tourist sites: the monuments, buildings, and mountains that are on picture postcards. There is nothing wrong with bringing home your own souvenirs, but your photographic appreciation and the enjoyment of those who see your pictures or slides will be highly rewarding if you go beyond the picture postcard.

■ IMPROVED SCENICS

With the worldwide communication that we have today, and with television in practically every home, the typical tourist sites are nothing new to most people. While enjoyable, most people prefer to see something new or at least see old things in a dif-

Shooting the dazzling lights of Las Vegas from a different angle creates a more unique look at a familiar attraction. Diagonal lines make for a more dynamic composition.

ferent way. There are many ways you can make your tourist pictures more rewarding to you and more interesting to your audience.

Try to photograph the well-known sites in a somewhat different way—perhaps from a different angle or from a different distance. It is probably not easy to find a better way. Professional postcard photographers have undoubtedly looked at the sites in many ways and have selected the most effective views for the tourist's souvenirs. For example, I tried to find a way of photographing the Taj Mahal differently, but discovered that the most beautiful view is from exactly the same point as it is photographed by everyone else.

Two different views of Niagara Falls—the Canadian Falls in the summertime look like a postcard picture (left), while the American Falls in January have a cold, unusual and moody appearance (right).

One solution is to photograph the statue, the building, etc., as it is seen in the tourist literature but then follow up the postcard view with a few additional pictures from different angles or distances—add some close-up views of the details. This is an especially effective approach when shooting slides and results in a more moving slide presentation. When you do this, you are essentially using the movie approach of combining long, medium and close-up shots. Your zoom or telephoto lenses will come in hand for this. Wide-angle lenses can also help, as they allow you to include foreground elements—a flower bed, a puddle of water, street signs—that may not appear in the picture postcard.

The easiest solution for creating a different image is offered by light. Photograph the site in the early morning or late afternoon instead of in the brilliant noontime sun usually found on the postcard picture. Strong sidelight with shaded and lighted areas may produce the desired difference. Create your images on an overcast, foggy, rainy or snowy day. It gives your images not only the "non-postcard view" but also a special mood. Photographing in a non-tourist season can also help. I find, for example, that Niagara Falls appears more dramatic when covered with ice and snow.

Top—A foggy day adds a special mood and feeling. It also makes our travel pictures different from a typical picture postcard. This is especially helpful when photographing well-known tourist sites such as this church in Bavaria.

Bottom—The early morning light can take on many different moods. Early morning fog in New Zealand adds a painterly effect to this photo.

An unusual view that will make every photographer look for the camera—even in the cold of a January day in Iceland.

A trip anywhere in the world will be more rewarding photographically if you don't limit your photography to the tourist sites. Try to come home with beautiful, perhaps unusual images of anything you see—the details in an iron gate, the colors on a boat, a line pattern in a field, a shadow pattern in a street, the reflections on water or store windows. These details need not be typical of that area, they may be the same things that you find at home. As long as such images are composed with an effective arrangement of lines, shapes and colors, they will become a part of your personalized memories.

In many parts of the world, markets take place daily, or at least once or twice a week. They are great places to become more familiar with the area and the people, and great places to use roll after roll of film. As everywhere, don't limit yourself to

overall shots. Get close. You will find wonderful arrangements of fruits, vegetables, handicrafts, jewelry, and whatever else they might sell. In most cases, photograph things as they are, where they are.

A good example of the picture material you find inside an antique store—here, in central Bali.

■ PHOTOGRAPHING PEOPLE

Don't forget the people. Photographing people anywhere in the world, but especially in other countries, can be a rewarding experience that brings you closer to the people. Even if you do not speak the language, there is usually some communication. Frequently, people take an interest in what you are doing. They want to know where you come from, and may also be flattered that you take an interest in them.

Marketplaces and flea markets are convenient places to get close to people. They are occupied with buying or selling and are frequently not even aware of your presence. If people see me with my camera, on the other hand, I consider it a common courtesy to ask their permission and not just point the camera at them. In most cases, people do not object and are happy being photographed. However, since you probably want candid, not posed pictures, you will only succeed if you work fast—even if the people know that they are being photographed.

Keep photography simple. A tripod is a burden and a nuisance. Leave it at home or in the hotel. Learn to hold your camera, even a medium format camera, steady. Practice before you go there. You should also take advantage of all the automation you may have in your camera—automatic focusing and exposure—or learn how to

focus and read the meter quickly. You will be most successful when you catch the picture before the people realize that they are being photographed. This is the case not only in areas where people do not like to be photographed, but even where they are flattered when you photograph them—in Indonesia, for example. You will get a candid, natural picture rather than a posed one. You can always take a posed portrait after you catch the people candidly.

In most marketplaces, people are in shaded areas under umbrellas, even on sunny days. You may not need a faster film, but 400 ASA instead of 100 will allow you to use higher shutter speeds. This reduces the danger of camera or people motion. It also allows you to shoot at a smaller aperture so that small focusing errors still produce a good or at least acceptable image.

People pictures can be successful in the candid fashion, with the people often unaware of being photographed. This photo was taken in Mexico.

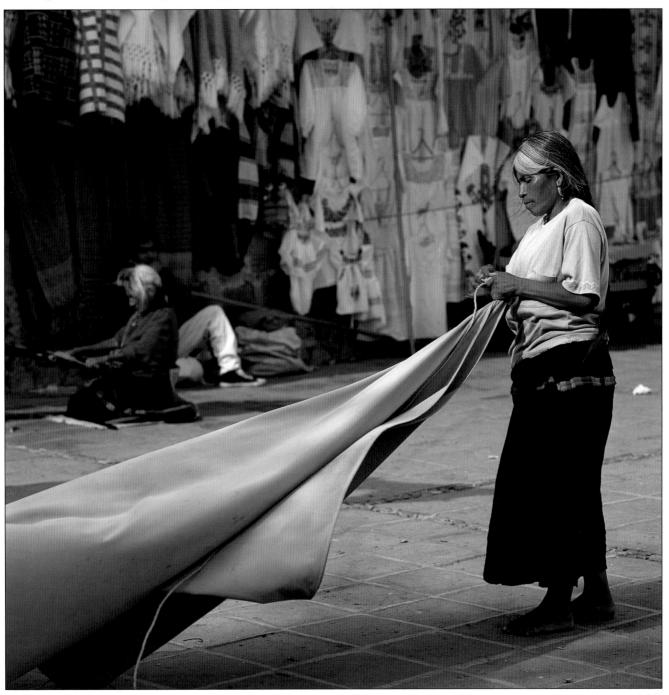

Here is a colorful example of photographing people outdoors. Notice how the bright colors—especially the combination of red and blue—enhance the image.

With the proper fast shooting approach, longer focal length lenses are not necessary and, in my opinion, not even recommended. They present more problems with camera motion and need a longer distance, which is frequently nonexistent in marketplaces. You want to be as close as practical. I have found lenses from 100 to 150mm to be ideal on my 6cm x 6cm medium format camera. They are equivalent to focal lengths between 70mm and 90mm on a 35mm camera. I would never "hide" with long telephoto lenses for this work. It would take away all my enjoy-

ment from people photography, and viewing such images would not bring back the memories of being with the people.

Flash is undoubtedly desirable in marketplaces, but will make you more visible as a photographer. You may want to forget about it in places where you don't want to create attention and do your best with the existing light. If you do use flash, keep in mind that in an outdoor market, the existing daylight must remain the main light source. It should not be overpowered by the flash. The flash should just be used to lighten the shaded faces and eyes of the people.

You only need a little flash since you are close to people and probably working at relatively large apertures. Do not take a large professional unit. A small compact

This image combines light and shade. It was taken in the late afternoon sunlight on Santorini in Greece.

Left—Ordinary everyday subjects can make interesting pictures too. This photo was taken in the early morning light in Vienna.

Right—In Chendu, China, this charming girl was in such a hurry to get to school that I limited my photography in the shaded street to ten seconds. The numbers on the building wall made the perfect backdrop.

unit mounted on the camera or the flash built into your camera is sufficient. Reduce the flash illumination, if possible, by two to three *f*-stops in relation to the daylight exposure. Set the flash fill function in a 35mm or medium format camera to -2 to -3. On a dedicated system where the flash exposure is controlled by the ASA setting, set the ASA to 400 or 800 for 100 ASA film, to 1600 or 3200 for 400 ASA film.

In places where people like your presence and like to be photographed, you can become a real hero if you can "reward" people with an instant photograph. So if you work with a medium format camera with interchangeable film magazines, attach the Polaroid film back after you finish your photography and take one more picture to donate to your newly made friends.

15 PHOTOGRAPHING PEOPLE OUTDOORS

DON'T WANT TO CALL THIS CHAPTER "OUTDOOR PORTRAITURE," AS THIS TERM IS commonly associated with and limited to the typical professional portrait approach for photographing groups or individuals with the final image framed and displayed in a dominant place in the home or office. Being part of the home or office decor, you want something that looks a little more like a painting. This "painted" feeling can be emphasized by the finishing of the print and the framing. Finishing the print often includes darkening the corners, which unfortunately, in many portraits, is done so excessively that it looks unnatural and objectionable. What I want to discuss here is not the "fireplace portrait" approach but just some better ways to take pictures of people we normally photograph—our family, friends, neighbors, or perhaps strangers that we use as nonprofessional models—and ideas that also work with professional models.

There are many simple ways to get away from the typical snapshot approach and to record people, especially young people, in a natural way—but also in a way where they look more like professional models. Your pictures can look more like illustrations from fashion magazines. As an additional benefit, I feel these ideas will make your photography more enjoyable, and that the images will give your "models" great enjoyment, especially twenty, thirty or forty years from now.

To photograph people well, we must get away from the approach of just photographing whoever stands in front of the camera in whichever way they stand there. Pay attention to the light, the background, the surrounding area, and help people with the pose.

LIGHTING

The choice of lighting is limited if the picture must be made outdoors at a specific location at a specific time. If the choice of time and location are open, your chances for success are unlimited.

Sunlight shining into people's faces must be avoided. Such light is flat and harsh, and people have problems keeping their eyes open. Sunlight, on the other hand, can be beautiful as a backlight or a sidelight. I recommend it especially for photographing young people. Sunlight adds a feeling of life and happiness and is therefore often used in fashion photographs.

To reduce the contrast between the lighted and shaded areas, you must add light to the shaded areas. This can be done with reflectors or flash. Flash is not only the THERE ARE MANY

SIMPLE WAYS

TO GET AWAY

FROM THE

TYPICAL

SNAPSHOT

APPROACH.

Another bright and colorful example illustrating the wonderful possibilities of photographing people outdoors. Fill flash and a Softar soft focus filter were used.

simplest and most practical approach, but also allows the model to move without worrying too much about the light. With reflectors, every change in the pose may require an adjustment on the reflector. Such a picture is more likely to become a static portrait. You want people, especially young ones, to be able to move, be alive, and enjoy themselves being photographed.

Flash also works well since people pictures are usually done at larger apertures to blur the background. This means you do not need much fill light and don't necessarily need to carry a big flash unit. A small flash unit, right on top or built into the camera serves the purpose well. The flash must appear just as fill light—hardly recognizable—since this is to be a daylight picture, not a flash picture. To achieve this, reduce the flash the equivalent of two to three *f*-stops for a natural looking daylight picture.

Since the flash is rather weak, I have never found a problem with red-eye effect—even if the flash is right on the camera. I suggest, however, enlarging the flash head surface with a little soft box, if practical, as suggested in the flash chapter. Such a box softens the flash light, making the use of flash even less noticeable. With it, the flash looks more like a natural fill-in light.

Pay careful attention to the sunlight. Used as hairlight, the light is usually more effective if it comes slightly from the side instead of from straight back. This corre-

A people picture made effective by the composition—placing the girl's dark hair against the bright background immediately attracts the eye and keeps it there.

Good outdoor people pictures start with the selection of an interesting setting that helps the model fall into a natural pose. Then, use the daylight in an effective fashion and consider improving the lighting with fill flash.

sponds to what a portrait photographer does in the studio. Avoid the sunlight hitting the tip of the nose. Such a highlight creates too much attention.

For the professional portrait photographer, the soft light of an overcast day or the diffused light in a shaded area is frequently preferred. Whether it produces a better picture is questionable, but the effect is more subdued yet not necessarily flat. Even on an overcast day or in complete shade, there is always more light coming from one side—you can see this clearly when watching the light on the model's face or body. Ask the person to turn the face or body in either direction and the subtle differences become more obvious. Your images will be better when you photograph into the

light, in the direction where the existing light produces lighter and darker areas on the face and body. This approach is especially effective in black & white work. With color film, flash can help even in the diffused light of an overcast day or shaded area. The flash may do no more than add a little light into the eyes, but it will also help to produce better colors under the unknown color qualities of the light. Adding flash will definitely result in better flesh tones.

Beautiful light (usually not requiring flash) exists on a foggy day. You end up with a beautiful portrait almost regardless of where or how you take the picture. Also, don't forget the early morning or late afternoon light. It can be softer, and certainly more beautiful, than the light produced by the midday sun. The warmer light,

Outdoor features, such as a tree trunk and branch, can often help achieve an interesting pose. The location was selected mainly because of the beautiful lighting pattern on the dress.

however, produces warmer flesh tones. This is not always objectionable and can be beautiful if the entire image conveys the early morning or late afternoon feeling. That means including a background area that conveys this mood. It usually works in a ³/₄ or full-length portrait, not in a head and shoulder portrait.

■ Location and Background

A main reason for photographing people outdoors is the variety of locations and settings that exist everywhere. The background is an important part of an outdoor portrait; it is the part of the image that can make it different from a portrait done in the studio. That is the reason why I personally like the square format for this purpose. The additional space on the side allows me to include more of the background area without making the person smaller. While this does not apply so much for a headshot, it certainly does for ³/₄ and full-length pictures. Including a larger background area is also the reason why many professional portrait photographers like to use wide-angle, or even fisheye lenses for this purpose.

To begin, select a location that enhances the image and is appropriate for the outfit the person is wearing. A country location (fields, forests) is fine for casual wear. For more formal wear, you may want to consider a town setting that includes beautiful or interesting architecture. Colors must enhance rather than distract from the image. A colorful background is great when the person is wearing white or black. For more vibrant outfits, subdued colors in the background are appropriate.

To reduce distraction, consider making the background somewhat out of focus or completely blurred by using a larger aperture and/or a longer focal length lens. Longer lenses also include a smaller background area and make it easier to eliminate distracting background elements—billboards, cars, or people, for example. With longer lenses, a slight change in camera angle can change the background drastically.

■ THE PROFESSIONAL TOUCH

Most fashion photographers will tell you that it is the styling, the clothes, the hair-style, and the makeup that make an "ordinary" person look like a professional model. While we probably will not use professional help for that purpose, volunteers who know something about clothes, can apply good makeup, and know how to style hair can always be found. Since most young women like to look like the professionals in the fashion magazines, ask your model to wear something that is not completely ordinary, something that flatters and enhances her character.

Once the "model" is in front of the camera, little suggestions from you can go a long way in making your model look like a pro. The best place to start is with the legs. Ask the model to place her weight on one leg. This allows the model to place the other leg almost anywhere—to the side, in front, crossed over the other leg, etc. It almost invariably results in a more graceful pose. Rather than just telling the model what to do, actually demonstrate it. Place your legs where you would like to see them. Next, suggest turning the body to one side and the other, perhaps combined with a slight tilt, which may result in a more graceful curved line. I usually worry last about the head, again asking the model to turn her head to one side and the other, watching both the pose and the lighting.

SELECT A LOCATION

THAT ENHANCES

THE IMAGE AND IS

APPROPRIATE FOR

THE OUTFIT

THE PERSON

IS WEARING.

The posed approach, in contrast to the candid one, gives the opportunity to pay more attention to the light and background. The posed approach must look natural.

Placement of arms and hands seems to be a major problem for many people. Whatever is done should be natural. They should be placed somewhere where the model might normally keep them—pockets, underneath a belt, on the cheek or chin, even in the hair or just floating out in the air. Almost anything looks better than having arms and hands just hanging down.

MAKE IT EASY

FOR THEM,

AND MAKE SURE

THEY ENJOY

WORKING

WITH YOU.

While trying out these ideas, make it clear to the model that you are just experimenting, not shooting, and that you will tell them when you are ready to take the picture. It is tiring for anyone to stand in front of a camera, watched constantly. Make it easy for them, and make sure they enjoy working with you. Their appreciation for your concern will be visible in the pictures.

Where do you get ideas for photographing young people? Look through the fashion magazines. There are always new ideas and trends in this competitive field. While some of the concepts are not usable for our approach, you will find many ideas regarding location, lighting, posing, and placement of arms and hands that you can duplicate. You can also use these illustrations to convey to your model what you are trying to accomplish.

These are some suggestions for producing better personalized portraits in your hometown or during your travels, while at the same time enjoying what you are doing. Keep in mind: good lighting is the most important key to success.

GLOSSARY

Advanced photo system (APS)—A relatively new film format, smaller than 35mm, that offers advantages mainly in film loading, printing and storing of images. The images can be recorded in three different formats: standard, wide and panoramic. The smaller format also allows for the production of more compact cameras.

Aperture—The size of the opening of the lens diaphragm. The maximum aperture of a lens is obtained by dividing the focal length of the lens into its entrance pupil (known to the lens designer).

Apochromatic lens—When designing photographic lenses, the designer is mainly concerned about correcting the chromatic (color) aberration for two colors, usually red and blue. Such a design can result in a high quality lens without noticeable color fringes in all but the longest focal lengths. Such lenses are known as achromatic. Eliminating color fringes completely, and producing the best edge sharpness in long focal length lenses, may require a lens that is corrected for three colors, usually red, blue and green. Such a lens is apochromatic. A third type, known as Super Achromat, is corrected for more than three colors.

Aspheric lens—Lens element with one or two aspheric surfaces. Such elements are used in some photographic lenses. Since aspheric lens elements are difficult to manufacture, lens designers will not employ them unless absolutely essential. They try to obtain the required lens quality with the use of spheric lens elements.

Average brightness—A subject that reflects 18% of the light is considered average brightness (gray card). Reflected light meters are adjusted to provide the correct lens settings for a subject of average brightness.

Bellows—A flexible connection between the camera and lens. It is usually an accessory for 35mm and

medium format cameras where it allows moving the lens further from the image plane for close-up photography. A bellows is also a part of most large cameras and some medium format types where it is used for focusing or for shift and tilt control.

Blurred motion—An unsharpness in the image that is caused by either the subject or the camera moving while the shutter is open. While unacceptable in most images where the highest quality is required, the blur can also be used effectively to convey the feeling of motion, (sports or water, for example). The slower the shutter speed the more enhanced the effect.

Cable release—An accessory attached to the camera to release the shutter without touching the release button. Recommended when working at longer shutter speeds to reduce the danger of camera movement. Some cable releases have a lock, helpful for very long exposures. A cable release is not needed for handheld photography.

Close-up photography—Refers to photographing small subjects from close distances. There is no standard setting dividing the line between close-up and long distance photography. The dividing line is frequently based on the minimum focusing distance of the lens and where the need for the use of close-up accessories starts. With macro lenses, a good range of close-up photography can be done without the need for accessories.

Composition—Making an effective, pleasing arrangement of lines, shapes and colors within the frame.

Dedicated flash—A camera/flash system where the flash unit is electronically dedicated to the camera, measuring the flash through the camera lens. A sensor in the camera measures the flash (usually reflected off the film plane) and turns the flash off when the proper amount for correct exposure is reached.

Depth of field—The range of sharpness in front of and behind the focused distance that is considered acceptably sharp in the final image. Depth of field is increased by closing the lens aperture. Depth of field is a calculated figure and not dependent on the lens design.

Digital camera—A camera where the image is recorded and stored electronically, not on film. Some medium format cameras can be used for digital recording by attaching a digital back instead of a roll film magazine.

Diopter—Term used to indicate the focal length of a lens, especially in eyeglasses. One diopter is equal to a one meter focal length. In photography, diopter is used in connection with close-up lenses and viewfinder eyepieces, in relation to correcting the camera viewfinder eyepiece to the photographer's eyesight.

Double exposure—When two or more images are recorded on the same piece of film, usually for creating a special effect.

Electronic flash—An excellent, bright source of light that can be used alone or in combination with daylight as both have the same color temperature. A large amount of light can be produced by a small and lightweight unit that can be mounted on the camera. Many cameras have a built-in flash.

Electronic imaging—Technology that allows images to be produced electronically, eliminating the need for film, film processing and the use of chemicals.

Electronic sensor—The light-sensitive microchip that records the image in a digital camera or digital back. Can be a CCD (charge-coupled device) or CMOS (complementary metal oxide semiconductor). Camera specifications indicate its size in the number of pixels it records, such as 2046 x 1536 (over three megapixels) or 3040 x 2016 (over six megapixels). A higher number of pixels is likely to produce higher image quality.

Exposure meter—A device that measures the light or the subject brightness and gives us the aperture and shutter speed figures. The meter can be built into the camera or can be a separate accessory.

Fill light—Light used in addition to the main light to add illumination to dark or shaded areas. Electronic flash or reflectors are usually used for this purpose.

Film plane—The position of the film in the camera body or film magazine. Focusing distances are always measured from the film plane.

Film reflectance—The amount of light that is reflected off the film surface. May have to be considered in a dedicated flash system where the sensor measures the light reflected off the film plane.

Film scanner—Device that allows you to scan (create digital images of) your negatives or transparencies so they can be stored or added to a website, as well as adjusted or enhanced in many ways.

Film sensitivity—Indicates how sensitive the film is to light, and determines the aperture and/or shutter speeds that are necessary to record a properly exposed image on the film. A film with a higher ISO number is more sensitive and therefore recommended in low light situations.

Filter factor—A figure indicating how much light a filter absorbs, thus requiring an increase in exposure when the filter is used. Filter factors are not, however, equivalent to *f*-stops.

Fisheye lens—Lens that is designed so the angle of view diagonally is much greater (usually 180°) in relation to the angle of view horizontally or vertically. They produce an image with curved lines outside the center area. Fixed focus—A lens found in point & shoot cameras that cannot be adjusted for different subject distances. The focal length is usually short and the aperture relatively small so that the depth of field covers a satisfactory distance range with acceptable sharpness.

Floating lens element—A wide-angle lens design where some of the lens elements can be moved. Used in retrofocus wide-angle designs to improve the image quality at close distances.

Focal length—Distance from the principal plane in the lens (known to the lens designer) to the point at which the lens forms an image of a subject at infinity. The focal length is always engraved on the lens. The focal length of a lens is the same no matter where or how it is used—and regardless of what image format it is to cover. The specifications for digital cameras often do not state the actual focal length of the lens on the camera, but the equivalent focal length on a 35mm camera. This makes sense due to the different sizes of electronic sensors in different digital cameras and digital backs.

Focusing hood—A foldable viewfinder that is standard on most medium format cameras. It is usually interchangeable with a prism viewfinder.

Focusing range—The minimum and maximum distances at which sharp images can be produced without the use of any accessories.

Focusing screen—In single lens reflex and large format cameras, the image is viewed on a focusing screen rather than an optical viewfinder. On large format and special medium format cameras, the focusing screen is added to the camera in place of the film holder or magazine. On single lens reflex cameras, the mirror projects the image to the focusing screen before the image is made. Focusing screens come in many different versions, and also with added microprisms, split image rangefinders, checked lines, etc.

Full-frame fisheye lens—An image produced in a full-frame fisheye lens covers the entire image area. Other fisheye lenses just produce a circular image in the center of the image area. Full-frame fisheye types have much wider applications.

High resolution film—A film with high detail and fine grain that is therefore capable of producing the utmost image sharpness. Films with lower sensitivities usually have these characteristics.

Hyperfocal distance—The distance setting on a lens that provides depth of field to infinity.

Image distortion—Refers to anything in the image that does not appear the way it looked to our eyes. Most image distortions are not created by the lens or camera but by the way the camera or lens was used. Image distortions can also be created artificially while the image is made or afterward.

Image perspective—The size relationship between subjects at different distances as recorded in the camera. Perspective in a photograph is determined by the camera position, the distance between the lens and the closest subject.

Image sharpness—A visual perception of the amount of detail that is recorded or recognized on the film or the final image. The sharpness of a photographic image is, however, not so much determined by the amount of detail that is visible but the edge sharpness within the subject details.

Incident meter—An exposure meter that measures the light that falls on the subject that we are photographing. The reading is unaffected by the brightness or color of the subject.

Interchangeable film magazines—In medium format cameras, the film may be loaded into a separate, removable film magazine. This allows changing from one type of film to another in the middle of the roll of film.

Internegative—A color print from an original color transparency is usually produced by first making a color negative from the transparency. This negative is called an internegative. The color print is then made from this negative.

ISO—International standard to indicate the sensitivity of a film. A higher number means a film with a higher sensitivity, a faster film. Identical to ASA numbers.

Large format—Refers to image sizes larger than the medium format, usually 4" x 5" or 8" x 10" recorded on sheet film.

Lens elements—A single lens within the camera lens. These lens elements may be single components in the lens or they may be cemented together with one or two other lens elements to form a lens component.

Lens plane—The position of the lens in relation to the image plane. The two must normally be parallel to each other. On large format and some medium format cameras, one can be shifted or tilted in relation to the other to increase the range of sharpness or eliminate the need for tilting the camera.

Lens shade—An accessory or part of the lens that eliminates unwanted light from reaching the lens and causing flare. A lens shade must be used even with multicoated lenses as the two serve different purposes. The lens shade reduces flare by eliminating the unwanted light, the multi-coating does the same but with the light needed to form the image on the film.

Loupe—A magnifying glass that is used to check the sharpness and quality of a negative or transparency. Such a loupe may show the entire negative area but in such a case is undoubtedly of a lower magnification. For examining image sharpness, a loupe with a higher magnification (8x or 10x) is preferable, even if it does not cover the entire negative area.

Low dispersion glass—The various lens elements within a photographic lens are made from different types of glass with the main difference being the refractive index of the glass. The refractive index refers to the angle at which the light is bent when it enters and leaves the glass. Low dispersion glass has an uncommon refractive index refers to the same than the control of the

tive index that may be helpful or necessary in designing certain lens types.

Macro lens—Usually a lens where the focusing control can be set to much closer distances than on an "ordinary" lens. Such a lens may eliminate the need for close-up accessories. The term "macro" may also refer simply to the fact that such a lens is designed optically to produce the best image quality at close distances.

Medium format—Film format larger than 35mm but not as large as 4" x 5". Combines some of the benefits and advantages of each. The most popular medium formats are 4.5cm x 6cm, 6cm x 6cm, 6cm x 7cm and 6cm x 8cm. Medium format images are usually recorded on 120 or 220 roll film.

Memory card—The device that stores the image in a digital camera. Equivalent to film in an ordinary camera. Mirror lockup—A feature found in some SLR cameras that allows moving the mirror manually from the viewing to the taking position before the image is made. This reduces the danger of the mirror motion producing unsharpness on the film.

Monopod—A single support post for the camera that, at shorter shutter speeds, can serve the same purpose as a tripod. A monopod is more convenient for carrying and faster to use. A monopod can be equipped with the same heads used on tripods.

Motordriven film advance—A camera where the film is advanced to the next picture by means of a motordrive. The motor can be built into the camera or can be an accessory motor winder that can be attached to the camera. Motordriven film advance may allow faster shooting. Being able to keep the eye in the viewfinder of the camera, however, is the major benefit of a motor winder in most photography.

MTF diagrams—The best and most widely used method to show the sharpness of a lens. With the Modulation Transfer Factor usually on a vertical axis, the curves of different spatial frequencies indicate the image quality over the entire image area. The idea is based on the fact that image sharpness as seen by our eyes is not so much based on the amount of detail we see (resolution) but on the edge sharpness. Some manufacturers publish these curves based on what the computer says the lens should produce, others are based on the performance of the actual lens as made and sold.

The latter is the only type that is meaningful.

Multi-coating—Used on all high quality lenses today. The coating reduces the amount of light reflected on the glass surface and thus reduces flare and increases the contrast and color saturation.

Panoramic format—An image format that is at least twice as long in one dimension as in the other. Such images can be produced in APS and special panoramic medium format and 35mm cameras. Panoramic images can be produced in some other cameras with masks or special magazines. The final image can also be changed into a panoramic by cropping.

PC card—A removable card that stores a larger number of data (pictures) in a digital camera. The image on the card can be viewed on a computer or TV screen or can be made into a print. In a way, the card is what a roll of film is in a film camera.

Perspective control—A feature built into special lenses, teleconverters or cameras that allows moving either the lens or the film in relation to the other. Eliminates or reduces the need for tilting the camera, which would result in slanted lines. Helpful or necessary for architectural work.

Photomicroscopy—The technique of taking pictures through a microscope.

Pixels—("**PIX**" for picture, and "**EL**" for element) Microscopic sensing points on the chip in digital cameras that read the light and convert it into digital signals. The higher the number of pixels, the better the resolution in the image. Three megapixels, for instance, means that the sensor has three million pixels.

Plane of focus—The plane at which the lens is focused. **Proxar lens**—Another name for a close-up lens that is mounted in front of the camera lens for photographing at closer distances.

Reflected meter—An exposure meter that measures the light reflected from the subject we are photographing. Exposure meters built into cameras are of the reflected type. The meter reading is affected by the brightness of the subject.

Retrofocus—A wide-angle lens design with a very long back focus (distance from rear element to image plane) that is necessary on SLR cameras where the mirror needs the space to move up and down. Wide-angle lenses on SLR cameras are of the retrofocus type. The

other wide-angle design, the optically true wide-angle type, is used on large format and special medium format cameras.

Shutter—A device that is open a specific length of time to let light go to the image plane. The shutter can be in the camera, usually in front of the image plane (focal plane type) or in the lens.

Shutter speed—The length of time that the shutter in the camera or lens is open to let light travel to the image plane to make the exposure.

SLR camera—A camera type with a mirror that projects the image to the focusing screen for viewing. The mirror moves out of the way for taking the image. SLR (single lens reflex) cameras always show the image as it is recorded in the camera. The image can also be viewed at the chosen aperture setting if the camera has a manual stop down control.

Spot meter—An exposure meter that only measures a small area of the subject. A spot meter can be built into the camera or be a separate accessory. The area that is measured is clearly indicated on the focusing screen in the camera or in the viewfinder of an accessory spot meter.

Subject brightness—The amount of light that is reflected off a subject, which must be considered when taking reflected exposure meter readings, and also when using automatic or dedicated flash.

Teleconverter—A lens design that is used together with a camera lens to increase the focal length of the lens. The teleconverter is mounted between the camera and lens. A 2x converter doubles the focal length of the lens, a 1.4x converter increases the focal length 1.4x.

Telephoto lens—A lens that has a focal length longer than the standard (50mm for 35mm, 80mm for the 6x6 medium format). Telephoto lenses are usually separated into short telephotos going up to about double the focal length of the standard and the longer types. A lens of the optically true telephoto design is physically shorter than its focal length. Most long camera lenses are of this design.

Transparency film—Records a positive image on the film, an image where the colors are the same as in reality, where black is recorded as black, and white as white. Such films are available for color and black & white photography.

Tripod—A camera accessory to support the camera for steadier operation than handheld. Necessary or recommended with longer shutter speeds and/or longer focal length lenses.

TTL metering—TTL stands for "Through The Lens." It is usually used in connection with a light-metering system that measures the light through the camera lens or a dedicated flash system that measures the flash reflected from the subject through the lens.

Viewfinder—The camera component that is used to view the subject (an optical viewfinder) or lets you view the image of the subject on the focusing screen (as on a single reflex camera).

Wide-angle distortion—Wide-angle distortion refers to three-dimensional subjects being recorded distorted (elongated) at the edges or corners of an image, especially when made with wide-angle lenses on any camera. Mainly caused because the image plane is flat. Definitely not a fault in the wide-angle lens design.

Wide-angle lens—A lens with a focal length shorter than the standard. There are two optically different wide-angle lens designs. An optically true wide-angle lens must be close to the image plane and can therefore not be used on SLR cameras. A retrofocus wide-angle lens is necessary for this type of camera.

Zone System—A subject evaluation and metering system where the different subject brightness values from white to black are broken down into ten Zones. Black & white film developing times are adjusted to produce a black & white negative of normal contrast (printable on #2 paper), no matter what the contrast range of the original subject might have been.

Zoom effects—Produced by changing the focal length (zooming) while the image is recorded in the camera. Zooming changes the image size while the subject or scene is recorded producing a streaking effect on the film.

Zoom lens—A lens design where the focal length can be changed within a certain range by moving some of the lens elements. The range of focal lengths is called the zoom range. True zoom lenses stay in focus when the focal length is changed, some require refocusing.

Index

Advertising photography, 7, 91 Aperture, 11, 23, 27, 30, 41	Composition, 14, 95–101 balance, 97 distracting elements, 99–100 foreground elements, 45 in square frame, 95–97 lines, 97–99 simplicity, 101 subject placement, 97 Contrast, 30, 60, 82–83, 101 Copying, 33 Cropping, 14 D Daguerrotype plates, 13 Depth of field, 10, 23, 36–38, 41 Digital imaging, see Electronic Imaging Distortion, 30–33 barrel, 31 pincushion, 31 wide-angle, 31–33 E Electronic imaging, 6 camera backs, 7, 16 CCD, 6, 8 CMOS, 6, 8 e-mail, 8 LCD, 6 manipulating images, 7 optical finder, 6 output, 8 PC cards, 6–7 pixels, 8 sharpness, 8 software, 7 website, 8 Exposure automatic, 6, 59	close-up, see Close-up photography color saturation, 55 filters and, 89 flash, 62–73 metering, see Metering multiple, 6, 16 overexposure, 55 negative film, 55 transparency film, 55 underexposure, 69 Zone System, 60–61 Extension tubes, 56 Eyeglasses, 19, 23 F Fashion photography, 7, 21, 24, 91 Film 35mm, 6 black & white, 8 cassette (APS), 17 color, 8 development, 10, 60 filtration of, 87 fogging, 15 grain, 8, 10, 16 high speed, 8, 10, 15, 73 image size, 13 interchangeable magazines, 13, 14–16 low speed, 15 negative, 6, 8, 10, 14–15, 71 Polaroid, 16, 26, 71, 79, 109 resolution, 36 roll, 13, 15 selection, 8, 16, 107 sensitivity, 10
---	--	--

Film(cont'd)	Flash (cont'd)	Lens (cont'd)
sharpness, 10, 13-14, 15	sync, 18, 66, 69, 72	hyperfocal distance, 38
transparency, 6, 8, 9, 14–15,	warming filter with, 71-72	low dispersion glass, 27
71, 83	with existing light, 63, 66-69	macro, 29
Filters	Fluorescence photography, 89-90	manufacturing, 27
aperture, effect of, 88	Focal length, 6, 8	MTF diagrams, 29
cleaning, 89	shutter speed and, 25	multi-coating, 30
color, 88	Focusing	number of elements, 27
exposure with, 89	automatic, 6, 40	protection, 85
fog, 89	close-ups, 79	retrofocus, 28
for black & white, 82-83	fixed, 6	soft focus, see Soft focus
for copying, 85	hood, 41	standard, 42-46, 103
for infrared photography, 88	lock, 40	telephoto, 8, 16, 33, 42-46,
gelatin, 72	plane of focus, 38–40	103
gray, 83	screen, 19–20	types, 27
haze, 85		wide-angle, 8, 27, 30, 42-46,
lens protection, 85	H	93, 103, 116
light balance, 83	Handheld photography, 10, 15,	zoom, 6, 28–29, 42–46, 103
neutral density, 83, 88	22–23	Lighting
partial, 88	Hasselblad XPan, 16	continuous, 87
polarizing, 85	Horizontals, 14	backlight, 79, 94, 112
quality of, 89	,	existing, 73, 109
skylight, 83, 85	I ·	filtration of source, 86–87
soft focus, see Soft focus	Infrared, 88	flash, see Flash
special effects, 82, 89	Internegatives, 10	fluorescent, 83
UV, 85	michiegatives, 10	hair light, 112
warming, 71–72m 83	L	incandescent, 83
Flash, 7, 62–73, 109		low, 8
applications, 72	Landscape photography, 91	mirrors, 79
automatic, 64	Large format, 7, 9, 13	modeling, 87
battery, 69	shift, 13, 38	overcast, 114
bounce, 71	tilt, 13, 38	ratio, 62
color, 71–72	view cameras, 13, 38	reflectors, 111–112
electronic, 71–72	Lens	sidelight, 111–112
filters with, 71–72	abberations, 27	sunlight, 111
dedicated, 64–66, 79	angle of view, 48	sunrise, 10
diffusion, 71	aperture, 27	tungsten, 73
duration, 69–70	apochromatic, 28	Location photography, 15
exposure, 69, 71–72	area coverage, 42–45	Loupe, 10
fill-in, 66, 69–72, 112	aspheric elements, 27	
handheld, 67	background coverage, 46	M
indoor, 72–73	characteristics, 27	Magnifying glass, 10-11, 14,
location, 67–69	close-up, see Close-up	35–36, 94
manual, 63–64	photography	Medium format, 7, 9, 13
on-camera, 14, 67, 69	color fringe, 28	Metering, 50–61
outdoors, 18, 112	computer design, 27	automatic matrix, 58
portable units, 71	covering power, 44	average subject brightness,
shutter speed, 67–69	fisheye, 46–48, 116	52–54
slave units, 72	fixed, 6	built-in, 56–58
small unit, 10	flare, 30	centering, 58
soft box, 71, 112	floating elements, 28	EV values, 52–55

Metering (cont'd)	Prints, 6	Tripod, 14, 22, 24–25, 50, 73,
gray card, 52-54	color, 10	106
handheld, 50	enlargements, 7, 10	ball head, 24
incident, 50	from transparency films, 10	reversible center, 78
middle gray, 52	making, 7	selecting, 24
reflected, 50	paper development, 10	shutter release with, 24
spot, 21	retouching, 7, 91	substitutes for, 24
TTL, 55–56	Projecting images, 6, 11–12	Twin lens reflex (TLR), 13
Mirror lockup, 23		
Monopod, 24–25	R	U
Motion	Refraction, 36	UV photography, 89–90
blurred, 6, 16, 25–26, 83	Resolution, 8, 13	1 8 1 77
focal length and, 25	, ,	V
Motordrive, 16, 20–21	S	Verticals, 14
batteries, 21	Sharpness, 8, 9, 37–38	slanted, 8
bracketing, 21	background, 42	Viewfinder
camera movement with, 20	foreground, 42	eyepiece correction, 18–19
handheld photography,	Shutter	focusing screen, 18
use with, 21	cold weather, 18	optical magnification, 19
portraits with, 21	electronic, 18	sharpness, 18
sequences with, 20	flash sync, 18	Vignetting, 49
	focal plane, 18, 69	Vignetting, 47
P		W
Panoramic images, 9, 15-16, 30	lens, 18, 69 mechanical, 18	
Perspective control, 9, 42–46,	release, 24	Wedding photography, 71, 73, 91
48–49	· · · · · · · · · · · · · · · · · · ·	Wildlife photography, 40
background coverage, 46	speed, 10, 23, 25–26 Slides, 6	<u>_</u> ¥ .
focal length and, 42–46	SLR cameras, 18–21	Z
shift, 13, 38		Zone System, 60
teleconverters, 48	Soft focus photography, 91–94 aperture, 93–94	Zoom effects, 42, 83
tilt, 13, 38	bleeding, 94	
Photojournalism, 7	degree of, 93–94	
Pinhole photography, 35	depth of field, 93–94	
Point & shoot photography, 6	filters, 92–94	
Portrait photography, 24	focal length, effect of, 92–93	
children, 21	lenses, 92–94	
expression, 21	with backlighting, 94	
flash with, 70–71	Special effects, 6	
group, 37–38	Sports photography, 16, 25, 40	
hairstyle, 116	Square format, 13	
lighting, 111–116	Studio photography, 15	
location selection, 116	Studio photography, 13	
makeup, 116	Т	
outdoor, 45, 111–118		
pose, 21, 116–118	Teleconverters, 33–34	
sharpness, 42	aperture, 34	
soft focus, see Soft focus	depth of field scale, 34	
photography	focal length, 33	
Posing, see Portrait photography	35mm format, 9, 13, 62	
smg, the solution protography	Travel photography, 102–110	

Other Books from Amherst Media

Lighting for People Photography, 2nd Edition

Stephen Crain

The up-to-date guide to lighting. Includes: set-ups, equipment information, strobe and natural lighting, and much more! Features diagrams, illustrations, and exercises for practicing the techniques discussed in each chapter. \$29.95 list, 8 % x 11, 120p, 80 b & w and color photos, glossary, index, order no. 1296.

Computer Photography Handbook

Rob Sheppard

Learn to make the most of your photographs using computer technology! From creating images with digital cameras, to scanning prints and negatives, to manipulating images, you'll learn all the basics of digital imaging. \$29.95 list, 8½x11, 128p, 150+ photos, index, order no. 1560.

Outdoor and Location Portrait Photography

Jeff Smith

Learn how to work with natural light, select locations, and make clients look their best. Step-by-step discussions and helpful illustrations teach you the techniques you need to shoot outdoor portraits like a pro! \$29.95 list, 8½x11, 128p, 60+b&w and color photos, index, order no. 1632.

Black & White Portrait Photography

Helen T. Boursier

Make money with b&w portrait photography. Learn from top b&w shooters! Studio and location techniques, with tips on preparing your subjects, selecting settings and wardrobe, lab techniques, and more! \$29.95 list, 8½x11, 128p, 130+ photos, index, order no. 1626

Wedding Photography: Creative Techniques for Lighting and Posing, 2nd Edition

Rick Ferro

Creative techniques for lighting and posing wedding portraits that will set your work apart from the competition. Covers every phase of wedding photography. \$29.95 list, 8½x11, 128p, full color photos, index, order no. 1649.

Professional Secrets for Photographing Children

Douglas Allen Box

Covers every aspect of photographing children on location and in the studio. Prepare children and parents for the shoot, select the right clothes capture a child's personality, and shoot story book themes. \$29.95 list, 8½x11, 128p, 74 photos, index, order no. 1635.

Lighting Techniques for Photographers

Norman Kerr

This book teaches you to predict the effects of light in the final image. It covers the interplay of light qualities, as well as color compensation and manipulation of light and shadow. \$29.95 list, $8\frac{1}{2}x11$, 120p, 150+ color and b&w photos, index, order no. 1564.

Handcoloring Photographs Step-by-Step

Sandra Laird & Carey Chambers

Learn to handcolor photographs step-by-step with the new standard in handcoloring reference books. Covers a variety of coloring media and techniques with plenty of colorful photographic examples. \$29.95 list, 8½x11, 112p, 100+ color and b&w photos, order no. 1543.

Infrared Photography Handbook

Laurie White

Covers black and white infrared photography: focus, lenses, film loading, film speed rating, batch testing, paper stocks, and filters. Black & white photos illustrate how IR film reacts. \$29.95 list, 8½x11, 104p, 50 b&w photos, charts & diagrams, order no. 1419.

Special Effects Photography Handbook

Elinor Stecker-Orel

Create magic on film with special effects! Little or no additional equipment required, use things you probably have around the house. Step-by-step instructions guide you through each effect. \$29.95 list, 8½x11, 112p, 80+ color and b&w photos, index, glossary, order no. 1614.

Family Portrait Photography

Helen Boursier

Learn from professionals how to operate a successful portrait studio. Includes: marketing family portraits, advertising, working with clients, posing, lighting, and selection of equipment. Includes images from a variety of top portrait shooters. \$29.95 list, 81/2x11, 120p, 123 photos, index, order no. 1629.

Basic Digital Photography

Ron Eggers

Step-by-step text and clear explanations teach you how to select and use all types of digital cameras. Learn all the basics with no-nonsense, easy to follow text designed to bring even true novices up to speed quickly and easily. \$17.95 list, 8½x11, 80p, 40 b&w photos, order no. 1701.

Essential Skills for Nature Photography

Cub Kahn

Learn all the skills you need to capture landscapes, animals, flowers and the entire natural world on film. Includes: selecting equipment, choosing locations, evaluating compositions, filters, and much more! \$29.95 list, 8½x11, 128p, 60 photos, order no. 1652.

Professional Secrets of Natural Light Portrait Photography

Douglas Allen Box

Learn to utilize natural light to create inexpensive and hassel-free portraiture. Beautifully illustrated with detailed instructions on equipment, setting selection and posing. \$29.95list,8½x11,128p,80full color photos, order no. 1706.

Photo Retouching with Adobe® Photoshop®

Gwen Lute

Designed for photographers, this manual teaches every phase of the process, from scanning to final output. Learn to restore damaged photos, correct imperfections, create realistic composite images and correct for dazzling color. \$29.95 list, 8½x11, 120p, 60+ photos, order no. 1660.

Portrait Photographer's Handbook

Bill Hurter

Bill Hurter has compiled a step-by-step guide to portraiture that easily leads the reader through all phases of portrait photography. This book will be an asset to experienced photographers and beginners alike. \$29.95 list, 8½x11, 128p, full color, 60 photos, order no. 1708.

Creative Lighting Techniques for Studio Photographers

Dave Montizambert

Master studio lighting and gain complete creative control over your images. Whether you are shooting portraits, cars, table-top or any other subject, Dave Montizambert teaches you the skills you need to confidently create with light. \$29.95 list, 8½x11, 120p, 80+ photos, order no. 1666.

Composition Techniques from a Master Photographer

Ernst Wildi

Composition can make the difference between dull and dazzling. Master photographer Ernst Wildi teaches you his techniques for evaluating subjects and composing powerful images in this beautiful full color book. \$29.95 list, 8½x11, 128p, 100+ full color photos order no. 1685.

www.AmherstMedia.com

More Photo Books

Are Available

Contact us for a FREE catalog:

AMHERST MEDIA **PO Box 586**

AMHERST, NY 14226 USA

Ordering & Sales Information:

INDIVIDUALS: If possible, purchase books from an Amherst Media retailer. Write to us for the dealer nearest you. To order direct, send a check or money order with a note listing the books you want and your shipping address. U.S. & overseas freight charges are \$3.50 first book and \$1.00 for each additional book. Visa and Master Card accepted. New York state residents add 8% sales tax.

DEALERS, DISTRIBUTORS & COLLEGES: Write, call or fax to place orders. For price information, contact Amherst Media or an Amherst Media sales representative. Net 30 days.

> 1(800)622-3278 or (716)874-4450 FAX: (716)874-4508

All prices, publication dates, and specifications are subject to change without notice.

Prices are in U.S. dollars. Payment in U.S. funds only.

Posing and Lighting **Techniques for Studio Photographers**

J.J. Allen

Master the skills to create beautiful lighting for portraits of any subject. Posing techniques for flattering, classic images help turn every portrait into a work of art. \$29.95 list, 8½x11, 120p, 125 fullcolor photos, order no. 1697.